SAN LUIS OBISPO COUNTY
OUTLAWS

SAN LUIS OBISPO COUNTY
OUTLAWS

· DESPERADOS, VIGILANTES AND BOOTLEGGERS ·

JIM GREGORY

THE
History
PRESS

Published by The History Press
Charleston, SC
www.historypress.net

Copyright © 2017 by Jim Gregory
All rights reserved

First published 2017

Manufactured in the United States

ISBN 9781625859266

Library of Congress Control Number: 2017945021

This book is dedicated to historian Dan Krieger and to two wonderful women named Elizabeth. Dan married one of them and I the other.

CONTENTS

ACKNOWLEDGEMENTS

When I first met Dan Krieger, he was my European history professor at Cal Poly–San Luis Obispo, and the problem with Dan's class was that he was such a superb storyteller that I would stop taking notes and listen, transfixed, to the stories. I am not ashamed to say that I stole some of the best ones and used them during my thirty-year teaching career at Mission Prep in San Luis Obispo and at Arroyo Grande High School, where I would teach Advanced Placement European history.

The same holds true for this book, as a quick glance at the bibliography will confirm. Dan's expertise on San Luis Obispo County history, including his encyclopedic knowledge of the dangerous 1850s, was an important starting point. In learning from Dan—for me, writing books is yet another chance to learn new things, and I never tire of this—I was able to rediscover the love I have for the county where I grew up and where I live today. Dan's wife, Liz, fills their home with a sense of welcome and with books. And books. And *more* books. Liz, a retired children's librarian, has the same love for learning and the talent for kindling that love in others that my Irish American mother had. Liz's wonderful curiosity—like Lincoln's ambition, "a little engine that knows no rest"—is miraculous and inspirational. So this book, by a teacher, is dedicated to two of the most excellent teachers anyone could hope for.

As always, I owe so many debts that I am worried I will miss some, and I probably will, but I owe the biggest debt to my wife, Elizabeth, who is forced to tolerate the kind of writer who works rather obsessively. Like

our three dogs—that would be Mollie, Wilson and Brigid—once I get a rawhide chew in my mouth, I refuse to let it go. It was that way with this book, and she put up with me during the months when it was being researched and written. I was, as I often am, vaguely lost somewhere in the wrong century. Thank you, Elizabeth.

Other debts are owed: Thanks to my ever-cheerful and encouraging editor at The History Press, Laurie Krill, for being in my corner always, and to copy editor Abigail Fleming. Former San Luis Obispo County sheriff Tim Storton was generous with his knowledge, primary sources and photographs and is a good man to have a cup of coffee with. Eva Ulz and her staff, especially digital collections curator Aimee Armour-Avant, at the San Luis Obispo History Center were tolerant and helpful, as was Paul Provence of the South County Historical Society, always ready with both practical and moral support. Society curator Jan Scott, too, is a constant inspiration, including in her wonderful work in directing the Readers' Theater that does so much to make South County history live again. Laura Sorvetti at Cal Poly's Special Collections and Archives is a kind of hidden treasure who I must reveal here; she is incredibly knowledgeable. Thanks also to Yuriy Shcherbina of the University of Southern California Libraries; Marilyn Van Winkle of the Autry Museum of the American West; Barry Lewis, San Luis Obispo County Law Library; Brittany Bratcher of the Mission Santa Barbara Archives; California State Archivist Jessica Knox-Jensen; and three excellent historians and writers: Michael Redmon of the *Santa Barbara Independent*, David Middlecamp of the *San Luis Obispo Tribune* and Jeffrey Radding of the *San Luis Obispo County Bar Bulletin*.

As always, any mistakes I made in the research and writing process belong to me alone. I also know that I haven't come close to telling *all* the stories there are to tell, but I had a duty to my editors to keep my story succinct, so that means some wonderful news: there are other books that will be need to be written by other writers. I also know I will disappoint some in failing to paint outlaws in a more favorable light, but this comes from the caution of someone whose passion, in college, lay in Latin American, and especially Mexican, history. I discovered, during my research, that *Californios*, or Californians of Mexican descent, were the victims of pernicious bigotry, and outlaws like Salomon Pico and Pio Linares became powerful symbols of resistance. But the overwhelming evidence of my research indicates that these men led violent lives that were supremely selfish.

ACKNOWLEDGEMENTS

I have tried my best, with inevitable lapses, to lead an unselfish life, and for that I thank the thousands of young people I had the honor to teach over the years. You are, of course, always in my heart, and this book is most of all for you.

THE MAIL RIDER

T he sound of the horse's hooves on the winter hardpan road punctuated the long ride, and as the sun set, the animal's muzzle began to show steam because the cold came so quickly. Now it was dark, and its rider had to admit that it was getting harder to leave the warmth of a December hearth. The horseman was nearing fifty now, in the middle of the century, and truth be told, he shouldn't have lived this long but he had an instinct for detecting death and pulling his horse up short of it. He'd been a mountain man, a trapper and an army scout, and most of his contemporaries were gone: the Comanches had finished Jedediah Smith, for example, near the Arkansas River and the Arikara did the same for Hugh Glass in 1833, fifteen years before, on the Yellowstone. They had died as young men, and James Beckwourth, perhaps because of his chameleon-like ability to adapt, as he'd done when he'd lived for years among the Crow people, was still very much alive.

There could be no greater contrast with morbid memories of cold scalped white men than the Christmas ribbons, the oak wood fire and the children who had surrounded the mail rider, Beckwourth, in the adobe ranch house he'd left sixty miles ago. He'd picked up the mail there, exchanging mailbags with the rider whose circuit had begun in Los Angeles. Beckwourth's circuit began in Monterey and ended in Nipomo at the home of a Yankee *ranchero* named William Dana, where he would make the turn and head back north again with a fresh horse. The mail riders' arrival at the home of a man like Dana, the master of Rancho Nipomo's thirty-eight thousand acres, would

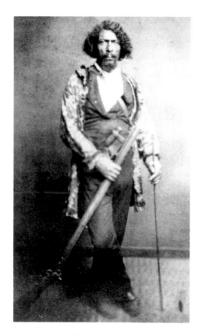

James Beckwourth, about 1860.
Smithsonian Institution.

have meant much more than a mere mail stop. It was a celebration, because the riders brought news of the outside world with them.

Dana, an educated New Englander, a former sea captain and a man of the world, would have been hungry for news, American news, because California, thanks to two years of war with Mexico, was now an American province. After greetings and a hot meal—beef and beans, onions and peppers and squash, all spooned into fresh tortillas—Dana would need Beckwourth, a colorful storyteller, to catch up with the news to the north, where gold had been discovered on the American River that January and where Dana's close friends, nearby ranchers Francis Branch and John Price, had taken a holiday in the slack winter weeks to do some prospecting on their own. The three were good businessmen, as well, and if the gold held out, their cattle would be needed to feed hungry miners. That meant deals to be made, cattle drives to be organized north and payment, in gold, to be brought home on the return trips south.

The small herd of Dana children would have ambushed Beckwourth when he'd ridden up to the house; he liked children, didn't mind them climbing on him, and there were seven young climbers so far at the Dana adobe and two more in their teens, nine of the twenty-one Dana and his wife, Maria Josefa, ultimately would bring into the world. They would lose half of them in infancy or a little beyond, including beloved five-year-old Adelina, named for Dana's sister, who had died the year before. The grieving parents had provided her a with a special burial in a little tomb in one wall of Mission San Luis Obispo.

Beckwourth's children were lost, too, but in a different way. There were four that he knew of, mothered by Crow and Mexican women he'd left behind in a lifetime of trapping, exploring, fighting and scouting and now, carrying the mail along El Camino Real, the old mission road that the Franciscans had traveled, north to Monterey.

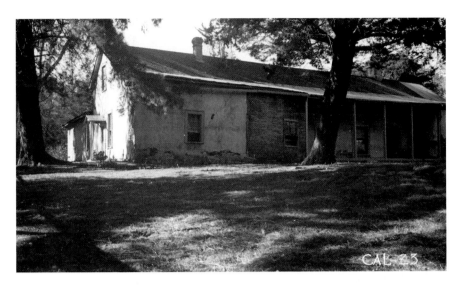

The Dana Adobe, 1930s. *Library of Congress.*

It was long enough between Nipomo and his next stop, San Miguel, so that as he got close, Beckwourth clucked encouragement to his mount, which responded eagerly because there would be oats and the great relief of a rubdown with blankets and a currying once the saddle and the mailbags had been removed. For Beckwourth, there would be the reward of another warm place with a family, the Reeds, and their servants, a kind of extended family, that he liked very much.

But even the horse might have sensed something wrong as they got closer, either in the scent that reached his nostrils or in the dark that cloaked the mission colonnade at San Miguel. There should have been light from a warmth of the kitchen fire and from flickering cow-tallow candles. Beckwourth should have heard the voices of both family and guests from William Reed's rooms in the old adobe outbuildings, now beginning their inexorable decay back into the California earth. There should have been the sound of children.

The mail rider's instincts, for once, almost failed him. Maybe he was getting too old. When he dismounted, slowly and stiffly, he walked cautiously into the mission grounds and toward the tavern kitchen the Reed family kept so well, along with their cook, one of the few black men, other than James Beckwourth, in this part of California.

The dark had come so quickly that Beckwourth tripped over something in the kitchen doorway. He kicked at it and it didn't move. When he

kneeled next to the obstacle and ran his fingers over it, he realized it was a corpse. Beckwourth sprang to his feet and went back to his mount to retrieve his pistols from their saddlebags. Lighting a candle, he went back inside the Reed family's quarters, the candle held high in one hand and a pistol in the other. He found a second body. It was a woman, bloodied as badly as Jedediah Smith or Hugh Glass had been. Then another. It was another woman.

The mail rider backed slowly out of the Reeds' rooms, then ran to his horse, swung into the saddle and galloped away, headed for the nearest rancho with the news of multiple murders. Beckwourth didn't know it—a skittish horse may have sensed it—but he hadn't been alone when he'd found the three bodies, and he was being watched as he rode into the darkness.

1

"A VAST PASTORAL DOMAIN"

*

Ninety-one years after the mail rider approached Mission San Miguel, documentary photographer Dorothea Lange captured the image of a rider in another part of San Luis Obispo County, in the Los Osos Valley, who might have been comfortable with a nonchalant nod of greeting had he met James Beckwourth on the road. Lange must have believed, as she took her photograph in February 1939, that she was seeing a figure in her viewfinder who belonged to another time.

In fact, her subject, the "cowboy coming in from the hills," as she titled the print, belonged very much to Lange's time, the eve of World War II. Cattle ranching was still an important part of rural California's economy. But in her photograph, there are visible connections to Beckwourth's century, as well. The horse in Lange's photo wears a thick noseband, evidence of a bitless bridle, a *bosal*, and the cowboy is wearing chaps—from the Spanish *chaparreras*—an innovation that, in central California, would have protected the rider as he plunged into the *monte*, the tangle of willow and scrub that bordered local streambeds, in search of a stray calf. What may have marked him, most of all, as an authentic cowhand was the thick coiled rope, called a *riata*, secured to his saddle. These features are characteristic of earlier cowboys, the working class of the rancho system of California between 1821 and 1848, during California's Mexican period. These were the *vaqueros*, among the finest horsemen in the world, who had inherited the technique, tradition and

This chapter borrows its title from an 1870s guidebook to San Luis Obispo County.

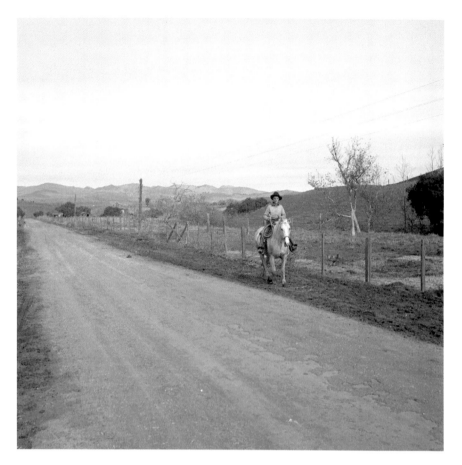

Cowboy, Los Osos Valley Road, by Dorothea Lange. *Library of Congress.*

compact, nimble horses characteristic of feudal Spain—the Mexica, or Aztec, had thought Spanish horse and its *conquistador* to be one person, and they weren't far from wrong. Iberian horsemanship had been passed on, centuries later, to the young California men who worked vast areas in tending thousands of head of cattle. The men who owned those cattle, the rancheros, relied on their herds to maintain both their livelihood and a tenuous connection, through offshore trade, between remote California and civilization.

The trade was based, not on beef, but on more durable goods: the hides and tallow of the cattle the vaqueros tended. Cattle hides, Santa Barbara historian Michael Redmon notes, were so important that they became the medium of exchange—they were called "California bank notes"—between California cattlemen and the American ships that called at Santa Barbara,

Monterey or, more perilously because of its lack of a wharf, at Cave Landing near Avila Beach. Eastern shoe factories were the primary markets for California hides; tallow, or beef fat, provided candles and soap. Rancheros like Arroyo Grande's Francis Branch prepared for the trade by rounding up their cattle for slaughter in June. Workers would then process the hides by soaking them in seawater, scraping them clean and drying them; this process and tallow production continued into the early fall.

Ships that participated in the hide and tallow trade included, in January 1835, the Boston brig *Pilgrim*, and one of its hands that winter was Richard Henry Dana, taking a leave of absence from Harvard to spend sixteen months along the California coast. Near Santa Barbara, Dana and his shipmates watched from the beach as Hawaiian workers shuttled hides to a ship's boat offshore; the Hawaiians formed a line, each man with one or two hides ("stiff as boards," Dana noted) balanced on his head. They made the run impassively through heavy breakers until the boat was full. Later that year, Dana thought himself lucky to escape a similar task assigned some of his shipmates. They were sent to pick up hides near Santa Clara. The ship's quarter-boat was gone for four days, its men drenched by constant rain, and the forlorn *Pilgrim* hands had to row thirty miles with the cargo to rendezvous with Dana and his shipmates aboard the brig.

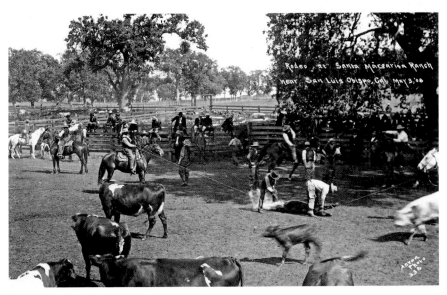

Santa Margarita cowboys branding calves, 1908. They are dressed and equipped much like mid-nineteenth-century *vaqueros*. *San Luis Obispo County Regional Photograph Collection, Special Collections and Archives, Cal Poly State University–San Luis Obispo.*

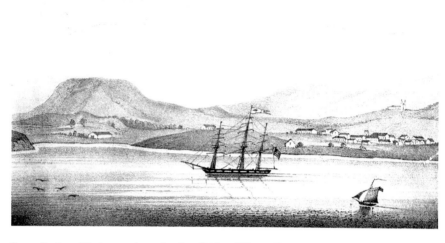

Santa Barbara Harbor at about the time Richard Henry Dana would have seen it. *University of Southern California Libraries/California State Historical Society.*

What Dana saw onshore during his visits to Santa Barbara and Monterey came through the Puritan lens he was born with. He was, after all, a New Englander who would someday, as historian Kevin Starr notes, marry "a girl of sound Connecticut Calvinism who reminded him of his mother." Dana praised Californians for their horsemanship. He excoriated them for what he saw as their vanity (a quality that irritated Puritans intensely—one thinks of Hester Prynne's rebellion in embroidering her scarlet letter), their indolence and, most of all, their spendthrift ways. He seems genuinely offended in this passage from *Two Years Before the Mast*:

> *The Californians are an idle, thriftless people, and can make nothing for themselves. The country abounds in grapes, yet they buy bad wines made in Boston and brought round by us, at an immense price, and retail it among themselves at a real (12.5 cents) by the small wine-glass. Their hides, too, which they value at two dollars in money, they give for something which costs seventy-five cents in Boston; and buy shoes (like as not, made of their own hides, and which have been carried twice around Cape Horn) at three or four dollars, and "chicken-skin" boots at fifteen dollars apiece.*

Dana, of course, is dead wrong, and had he ever visited his elder cousin at Rancho Nipomo, he would have been impressed with the self-sufficiency

of the residents. William Dana's son, Juan, provides glimpses of his father's ingenuity in his memoirs *The Blond Ranchero*. Dana and his workers, Indians and native Mexican-descended Californians (*Californios*), made their own soap in a five-thousand-gallon boiler and candles, as well, from their cattle, but also used the animal to make the vaqueros' rope, the rawhide thongs that held Casa Dana together—Juan notes that not a single nail was used in its construction. With leather plentiful, a shoemaker lived in an adobe near the main house provided the multiplying family with footwear. A smithy provided shoes and tack for the ranch's horses; a spinning room turned out fine cloth as well as *yerga*, a coarse woolen cloth for everyday wear; a milk room provided cheese and butter stored in barrels made by a cooper in the carpentry shop; sugar was made from white beets that grew near Oso Flaco Lake; dyes came from local root plants; and, Juan notes with a certain reserve, "Father had a still where he made a little whiskey for trade purposes."

Had he traveled a few more miles north, the sailor Dana would have seen the same kind of self-sufficiency at the rancho east of Arroyo Grande

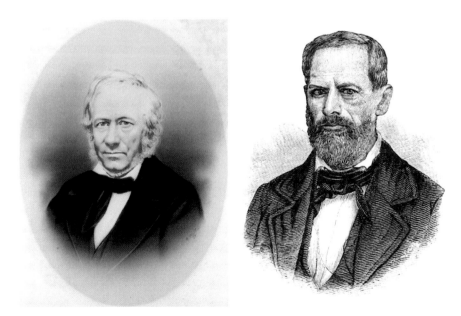

Left: William G. Dana, owner of Rancho Nipomo. *San Luis Obispo County History Center.*

Right: Francis Branch, owner of Rancho Santa Manuela, in the Upper Arroyo Grande Valley. *South County Historical Society.*

of William Dana's friend Francis Branch, a hard-headed, practical New Yorker, who had from the outset intended that his rancho, the seventeen-thousand-acre Santa Manuela, be a multidimensional enterprise. Besides the cattle he ran for the hide and tallow trade, Branch grew vegetables, raised sheep, supervised a dairy and built a mill, for which today's Branch Mill Road is named, that ground the Arroyo Grande Valley's flour. Granted, both Dana and Branch depended on the trade with Yankees offshore for luxury items and manufactures—bolts of silk and finished dresses, perfumes and firecrackers, as well as Branch's pride and joy, a corn-sheller—but the resourcefulness and ingenuity of a typical San Luis Obispo County ranchero was, sadly, a quality that Dana never had the chance to appreciate.

The administration of one of these ranches, which might employ as many as sixty people, mostly Chumash Indians, generated a distinctive hierarchy. Historian Leonard Pitt describes Rancho Santa Ana in today's Orange County:

> *The cacophony of barking dogs, clucking chickens, and shouting children bespoke the conventional way of life. Scores of employees buzzed about the place—wool combers, tanners, and vaqueros; a butter-and-cheese man, a baker, a harness maker, a shoemaker, a jeweler, a plasterer, a schoolmaster, a carpenter, and a majordomo; errand boys, shepherds, and cooks; also washerwomen, seamstresses, gardeners, viniculturists, and assorted hangers-on from the neighboring Indian* rancheria. *It took ten steers a month to feed this veritable army. Besides, Santa Ana was the social center of the region and welcomed many guests.*

California social life centered on a ranchero's family, and it was the daughters of these families who attracted so many Yankee sailors who were, perhaps, less judgmental than Dana. They married California girls and did so prodigiously. William Dana married Maria Josefa Carrillo, and her family was one of the most prominent in California. Captain John Wilson, whom the author Dana met during his 1835–36 voyage, also became a San Luis Obispo County ranchero, owner of Rancho Cañada de Los Osos y Pecho y Islay once he'd married another Carrillo, a striking widow, San Diegan Maria Ramona Carrillo de Pacheco. Isaac Sparks of the Huasna Rancho married Maria De Los Remedios Josefa Eayrs; her mother was a Californian, her father a ship captain and sometime smuggler who was so American that his full name was George Washington Eayrs. A generation later, Captain Marcus Harloe would marry one of Sparks's daughters, Manuela Flora.

The hospitality of Mexican California is suggested in this 1930s photograph of the porch adjoining the garden of the de la Guerra family's home in Santa Barbara. *Library of Congress.*

Dana, of course, would forsake the charms of young California women for what would sadly become a tedious marriage ensnared in Calvinism, but even he was charmed by a marriage he witnessed in Santa Barbara in January 1836. It was the union of yet another Yankee sailor, Alfred Robinson, to Ana Maria de la Guerra, the sixteen-year-old daughter of the commander of the Santa Barbara presidio. In late 1834, Robinson wrote a plaintive but touching letter to the *commandante*:

> *For some time I have wished to speak with you regarding a matter so delicate that, in the act of explaining it, words have failed me to express myself as I should in order to reveal the service which only you have the power to grant and to be the author of my felicity....Her attractions have persuaded me that without her I cannot live or be happy in this world, consequently I am begging for her hand....Your obedient servant, who kisses your hand.*

Dana was immensely proud as the newlyweds emerged from the Santa Barbara mission, because *Pilgrim* and its four ship's guns were part of the celebration. He and his crewmates pulled off a handsome twenty-seven-gun salute to greet the young couple, and the festivities that followed were typical of rancheros: three days of barbecuing, music and dancing (an art for

which Californians were noted), as well as free-flowing wine. The sailor also seemed charmed by one wedding custom:

> *The great amusement of the evening—which I suppose was owing to its being carnival—was the breaking of eggs filled with cologne, or other essences, upon the heads of the company. One end of the egg is broken and the inside taken out, then it is partly filled with cologne, and the whole sealed up. The women bring a great number of these secretly about them, and the amusement is to break one upon the head of a gentleman when his back is turned. He is bound in gallantry to find out the lady and return the compliment, though it must not be done if the person sees you.*

If sea captains, tough men like Dana and Robinson, were so susceptible to the allure of Mexican California, modern Californians' tendency to romanticize the period is understandable. But Mexican California was short-lived; it lasted a single generation. It was a fragile society born from conflicting ideologies: Mexico's 1821 independence movement had appeared in California as a clash between Enlightenment secularism and the power monopolized by the Franciscan missions, a monopoly that was resented intensely by young Californios who read their Voltaire and Rousseau while surrounded by a deeply devout population. Ironically, this modernist thinking was popular among a social class whose wealth was based on a feudal economy. California ranchos were reflective of old-world fiefdoms, and the Indians, no matter how well treated by local rancheros, were essentially serfs. (It was an attachment, for people like the Chumash, that was ultimately fatal; their numbers were decimated by diseases like smallpox and cholera.)

Disunity was another problem. Today's rivalry between San Francisco and Los Angeles baseball fans goes back to a rivalry just as intense between *norteños* and their provincial capital at Monterey, and the ranchers of the "cow counties" of Southern California, who, when their faction was in power, moved the capital to Los Angeles. There were two rebellions: in 1836, a Mexican governor was overthrown because one feeling many Californians shared was their antipathy to Mexican rule, which they resented as much as they had the Spanish Crown. The last governor of the Mexican period, Pio Pico, came to power after a second rebellion ejected a second governor appointed by Mexico City.

Another factor that may have doomed Mexican California was the guileless habit of extending hospitality to strangers. Ranchos like Dana's

were hostels in a remote and wild country, and guests were celebrated. (This was a custom that had tragic consequences for Arroyo Grande's Francis Branch; a guest welcomed into the Santa Manuela adobe in 1862 brought the smallpox that would kill three of Branch's daughters that year.) In the north, rancher and politician Mariano Vallejo extended a warm welcome to the trickle of Americans beginning to arrive from the east via wagon train. Marriages between young and prominent women and Yankee shipmasters—provided the Americans, as suitors, accepted both Catholicism and Mexican citizenship—are indicative of the fact that the Californios genuinely *liked* Americans. Even the hide and tallow trade meant that contact with United States was, in some ways, more frequent and, because of the trade goods, much more gratifying than Californios' contact with Mexico City, over two thousand miles distant from Monterey. The problem, finally, in this constant and amiable contact with Americans was that the Americans refused to go away.

When the Americans came south from Monterey to what is today San Luis Obispo County in the rain-driven winter of 1846–47, there was a distinct difference from any contact that had come before. Mexico was at war with the United States, a war that made its presence known in San Luis Obispo County in the person of the audacious and impulsive explorer and U.S. Army officer John C. Frémont. His followers in what was called the California Battalion included military engineers, rough frontiersmen who were the veterans of the short-lived Bear Flag revolt in 1845 and a fearsome bodyguard of Walla Walla Indians whose war paint had been smeared by the rain. Frémont's men were heavily armed, and this time they intended, not to settle California, but to conquer it, in a march south to capture Los Angeles.

True to the personality of the leader, the California Battalion had spread chaos during its sodden march southward. The combatants confiscated horses and cattle (one observer swore the battalion slaughtered up to fourteen cattle a day, calculating that the daily diet of each man worked out to ten pounds of beef), and Frémont had disrupted the peace of little San Luis Obispo with a spirited mounted charge into town. The townspeople were terrified by the rough and seemingly murderous looks of Frémont's men. The colonel kept them busy by having them throw up earthworks in the center of town and kept himself busy by ordering the court-martial and execution of Don Jose de Jesus Pico, a relative of Andres Pico, the commander of the Californio resistance in Los Angeles, and Mexican governor Pio Pico. That sentence was commuted by Frémont once his resolve had melted during an audience

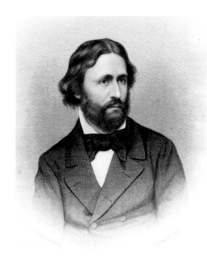

John C. Frémont as the Republican Party's presidential candidate, 1856. *Wikimedia Commons.*

with tearful women, relatives of Pico's, who successfully begged for his life.

The battalion then marched south to William Dana's Rancho Nipomo, where a delighted Frémont sat Dana's eight-year-old son, Juan, on his lap, charmed Doña Maria Josefa Dana with his good looks and manners and wrote out an IOU in government scrip to buy the horses he needed to replace the battalion's exhausted mounts. Dana was noncommittal when the colonel asked his advice for the best route south to Los Angeles but advised him to confer with his neighbor to the south, ranchero Benjamin Foxen. When the battalion left, Dana discovered that Frémont had taken some of Rancho Nipomo's best horses, animals that had not been part of the deal the two had struck. The ranchero responded with restraint, sending a few vaqueros and a bell mare south to Frémont's next campsite, in Foxen Canyon, to retrieve his horses. They followed the bell mare home. Foxen, meanwhile, learned of a plot to ambush the battalion in the Gaviota Pass, so his sons guided them instead through the San Marcos Pass. Frémont took Santa Barbara, as he had San Luis Obispo, without resistance.

Frémont would occupy Los Angeles in January 1847 and then negotiate a peace treaty made possible by a battle in which the California Battalion had played no part—the Californios were instead defeated by American forces jointly and uneasily commanded by Commodore Robert F. Stockton and Brigadier General Stephen Watts Kearny. Afterward, Stockton, a Frémont booster, appointed the colonel the military governor of California, but Kearny, recognizing the disruptive, and, when it came to cattle and horses, larcenous, record of the battalion, ordered it disbanded and had Frémont tried and dismissed from the army for insubordination. It was an inglorious end to Frémont's part in the American conquest of California; a year later, San Luis Obispo County would officially become part of the United States in the Treaty of Guadalupe Hidalgo, concluded at the end of the Mexican War.

Historian Leonard Pitt argues that the war, including Frémont's comic-opera part in it, was not quite the "conquest" it seems to have been.

The annexation of the Mexican Cession, including California, was the culmination of the Manifest Destiny—the belief that America was ordained to spread to the shores of the Pacific—championed by Frémont's father-in-law, the powerful Senator Thomas Hart Benton. But acquiring California may not have required military action; many Californios, including powerful landowners like Mariano Vallejo and Juan Bandini, were, in fact, open in their warmth toward the United States, whose power and constitutional government they admired, and hinted that some kind of "voluntary association" with the Yankees would be welcome. The fact that the Californios resisted the Americans—the most important battle of the California campaign was an American defeat at the hands of Californio lancers—came because American aggression had forced their hand. They felt a moral obligation to defend Mexico, ironically, the mother country with which they had so many quarrels of their own.

The Treaty of Guadalupe Hidalgo brought peace between the United States and Mexico, but not to California. Nine days before it was signed in February 1848, gold was discovered at Sutter's Mill. California would soon be overwhelmed by a flood of gold-seekers, and many of them would settle here to become productive citizens. Other newcomers would stop at nothing, including murder, in their single-minded hunt for gold.

2

"LEFTENANT, THEY KILLED THEM ALL"

In 2016, workers digging twenty-five feet beneath the surface of San Francisco's Financial District found, next to the Old Ship Saloon, the skeletal remains of the old ship. The saloon affords account executives nachos, beer and a view of the Transamerica Pyramid. But its earliest incarnation, buried beneath the fill dumped at the water's edge after the 1906 earthquake, was the three-masted ship *Arkansas*. What brought *Arkansas* from New York to San Francisco in 1849, the second year of the Gold Rush, was a passenger list weighted heavily with Methodist missionaries determined to bring the Word of God to benighted mining camp towns, like Fiddletown and Angels Camp, Hangtown and Peppermint Creek, places where "there is a good deal of sin and wickedness going on," as a new arrival from New York observed in 1850.

For the *Arkansas*, a career of sin and wickedness began soon after the end of a miserable trip from New York with 112 sickly passengers. The ship had run head-on into powerful storms, and the passengers ran out of food. Three died. The elderly vessel completed the unlucky voyage by running aground on Alcatraz Island. The *Arkansas* was so badly damaged that it was all the crew could do to limp across the bay and beach the ship on Pacific Street. *Arkansas* was then stripped of its masts—precious in a lumber-hungry town—a hole was cut into its side and it began a series of very un-Methodist careers, as a saloon, a brothel, a storehouse and a saloon once more, until it was finally dismantled down to the keel in 1857. The year after the 1906 earthquake and fire, the Old Ship Saloon was built on the site, which had

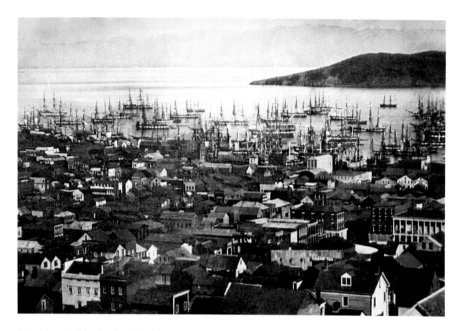

Abandoned ships in San Francisco Harbor, 1851. *Library of Congress.*

been covered over by earthquake debris dumped into the bay. The *Arkansas* reappeared in 2016, revealing timbers, a fifteen-foot section of keel and remnants of Gold Rush life, including shoes and bottles.

Arkansas was not alone in its fate. Contemporary photographs of what was still called Yerba Buena Bay show scores of abandoned ships, many of them destined for beaching as well, and a horizon dense with their masts. Their crews had set out for the mining camps, where there was sin and wickedness—and gold.

Meanwhile, as the Mexican War was ending, California was in a kind of political limbo. It was a conquered province, not a federal territory, and two years away from statehood. The government was fragile: a military governor, Colonel Richard Mason, was not quite sure that his authority ought to extend over civilians, and he relied on a network of *alcades*, justices of the peace inherited from the Mexican years, to provide a semblance of law and order over the vast territory over for which he was responsible.

And then gold was discovered.

In 1848, the first wave of gold seekers began to abandon San Francisco and the ships in the bay once a businessman and newspaper publisher, Sam Brannan, arrived in town in May with a glass vial of gold flakes, bellowing

the news to anyone within earshot. His newspaper immediately picked up the story, and now even the tenuous hold that Colonel Mason had over the American military was threatened by gold fever. U.S. Navy commodore Thomas ap Catesby Jones, who had returned to the California coast after prematurely claiming the territory for America in 1842, fretted that "[f]or the present, and I fear for years to come, it will be impossible for the United States to maintain any naval or military establishment in California.…[T]o send troops here would be needless, for they would immediately desert [for the gold fields]."

Jones's fears were borne out by his own branch of the service in the experience of the sloop of war *Warren*. *Warren* was a twenty-gun ship nearing the end of a career that had included fighting Greek pirates in the Mediterranean and protecting American shipping in the West Indies. By 1846, *Warren* had anchored in San Francisco Bay, doing tedious duty as a stores and receiving ship; it was essentially a floating commissary. In November, the captain ordered a launch, two warrant officers and a crew up the Sacramento River with $900 owed John Sutter, the entrepreneur and rancher. A little more than a year later, gold would be found on Sutter's land. But *Warren*'s launch was lost. It simply vanished, and search parties prowling the Sacramento never found it. The story eventually came to light: the boat crew had cut the throats of their officers, taken the money and scattered.

The news of the gold discovery at Sutter's Mill would have done little to improve the morale of a seemingly unhappy ship like *Warren*. In the fall of 1848, two *Warren* crewmembers, both Dublin-born, both named Peter, deserted the ship. Inexplicably, instead of heading east for the diggings, Peter Quin and Peter Remer headed south along El Camino Real and took up lodgings in the crumbling outbuildings of Mission Soledad, an isolated and melancholy place in the Salinas Valley. They bided their time there until December, when two horsemen appeared, riding from the north—two men, as it turned out, who were killers. Once they'd met, the daring and ruthlessness of the new arrivals at Soledad would impress the two deserters, inspire fear in them and ultimately lead them to their doom.

If desertion remained a threat to military discipline, the lawlessness that military men like Mason and Jones feared was amazingly absent in the gold fields. The fever had not yet reached the denser population centers of

the East Coast, nor had it begun to attract young men who would come to California from places as far away as France, Australia, Sonora, Mexico (so many Sonorans that a Gold Rush town adopted the state's name) and Chile. The great migration, one of the greatest in American history, would begin in 1849.

But in the late summer of 1848, when Colonel Mason and his aide, a young Lieutenant William Tecumseh Sherman, toured the gold fields, the first miners panned streambeds or burrowed into the ground within sight of one another and without conflict. Mason saw very few guns and no pretext for their use; the men had informally agreed on the boundaries of their claims and worked intently on them. The peace was disturbed only by an occasional gleeful yip when a pan revealed gold flakes. The men would look up momentarily and then return to their work. This respectful spirit extended to something almost as precious as gold: letters from home. Miners would form a queue at the designated post office, whether a tent or shanty, and man's place in line was sacrosanct.

The quiet in the gold fields was dictated by supply and demand; there seemed, in that first year, to be a limitless supply of gold and a relatively small number of miners. From 1849 until the first discovery began to play out in the 1850s, that changed dramatically. By then, 300,000 people, overwhelmingly

A contemporary cartoon satirizes the frenzy set off by the discovery of gold in 1848. *Library of Congress.*

young and male, had arrived in California; San Francisco's population grew from 800 in 1848 to over 25,000 by the end of 1849. The competition generated by the influx of miners inevitably generated violence fueled by frustration—mining was hard work and the nuggets, after all, were not there for a man to dig up as easily as if he were harvesting potatoes—by increasing conflict over boundaries between claims, by ethnic and racial rivalries, including violence against Latinos and Chinese, and by alcohol abuse. The homicide rate, for example, during the 1850s in Tuolumne County was 129 per 100,000. By comparison, New Orleans, the deadliest city in America between 2010 and 2015, had a rate of about 46 per 100,000.

One California county's homicide rate exceeded Tuolumne's in the 1850s: the murder rate in San Luis Obispo County was the equivalent of 178 per 100,000.

Perhaps the first murder of the California Gold Rush era came where gold had first been discovered by James Marshall in 1848, at Sutter's Mill. The sawmill had been transformed into sleeping quarters for the first wave of miners, and in October, one of them was Peter Raymond, a veteran of Frémont's California Battalion, the rough-and-tumble men who had so terrified the citizens of San Luis Obispo in the winter of 1846. Two years later, Raymond was staying at the sawmill when he got drunk and began a disturbance as tired miners tried to sleep. When one of them, Joseph Von Pfister, interceded, Raymond pulled the knife from Von Pfister's belt and stabbed him to death. The killer was disarmed, escorted to Sutter's Fort and placed in a cell, but he somehow escaped. Raymond linked up with a German-born man named Joseph Lynch, another Mexican War veteran, and headed for the coast.

By the time Raymond and Lynch rode into sight of Soledad, they were flush with gold from the diggings. They'd acquired it by murdering two men who had been their traveling companions during the trip across the San Joaquin Valley. The killing had just begun.

Petronilo Rios was evidently a shrewd man. He retired from the Mexican army in 1840 after having served two decades as a soldier, culminating with the artillery command at the Presidio in Monterey where he met and married Catarina Avila in 1832. He had also been part of the guard detail for Mission San Miguel Arcangel in northern San Luis Obispo County, and

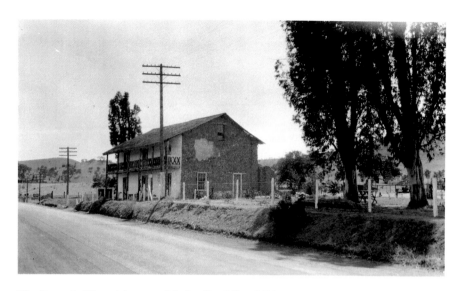

The Petronilo Rios adobe, near Mission San Miguel. Rios was murder victim William Reed's business partner; he would preside over the burials of the family and their servants. *San Luis Obispo County History Center.*

as his family grew to twelve children, he began to acquire land, including, in 1845, Rancho de Paso Robles, where he ran nearly one thousand cattle. The next year, he and a business partner, a young English-born family man named William Reed, purchased the nearby San Miguel Mission and its grounds from Governor Pio Pico just before California passed into American hands. While Reed, his wife and young son lived in the Mission buildings, Rios began to refurbish a house just south of the mission, today's Rios-Caledonia Adobe, while he and his family lived on their Paso Robles rancho.

The Reed family quarters at the Mission was a frequent stopping place for travelers, including the mail rider James Beckwourth, and Reed seems to have been an open, friendly man, welcoming of company. Like his business partner, Reed was ambitious; in late 1848, he'd just returned from a trip to the gold fields—like other entrepreneurs, Levi Strauss and his jeans being the most famous example, Reed realized there was money to be made, not in panning for gold, but in supplying the needs of the mining camps. His trip had been profitable; he sold a herd of sheep destined for hungry miners and brought home payment in gold.

The mission buildings were full of people as the winter cold began to settle in. There were nine others at San Miguel besides the just-returned Reed: Maria Antonia, his wife, said to be the natural daughter of one of the

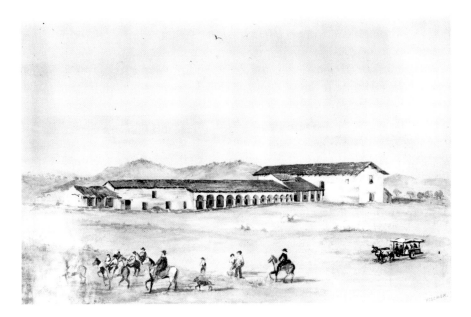

Mission San Miguel. *Library of Congress.*

most prominent Californios, military officer and ranchero Mariano Vallejo, imminently expecting their second child; their four-year-old son; Maria's brother, José Ramon; Maria's midwife, Josefa Olvera; two more members of the Olvera family, a fifteen-year-old girl and a male child; the family's cook; and, finally, a Native American shepherd and his young grandson.

On December 4, the Reeds and their friends were joined by some young men coming down El Camino Real from the north, from the Salinas Valley. Two of them, Peter Raymond, who now called himself "Mike," and Joseph Lynch, were on horseback. Four were walking: the two USS *Warren* deserters, Peter Quin and Peter Remer; another ship-jumper named Barnberry; and a Native American only identified as "Juan." Juan was ostensibly the travelers' guide; the three deserters had joined up with Raymond and Lynch because the two had gold, were willing to show it off and, unlike the three sailors, their lives stalled at the bleak mission at Soledad, the two men on horseback seemed to have some kind of destination. So they joined and made a party of six as they arrived at San Miguel at about three o'clock in the afternoon.

The visitors stayed to eat and, before retiring for the night, chatted with an amiable Reed, who made a fatal mistake. After he agreed to exchange some of the gold that Raymond and Lynch had stolen for cash, Reed remarked that his sheep sales had gone so well that his four-year-old couldn't lift the

pouch full of gold that he'd brought home to the mission. Reed and his family would be dead within twenty-four hours.

The next day, December 5, the six were up early and on the road by seven o'clock in the morning. They traveled no more than a mile before they stopped. The horses were tired, but there was another reason for the stop. "Some of the boys began disputing," Joseph Lynch later recalled, "saying that Read [*sic*] had a great deal of gold, and that it would be best to take it—we then decided to turn back, which we did, and stopped at the Mission all day." Reed seemed genuinely glad to see them, and to help pay for their stay another night, he asked them to cut down some trees for firewood. The six were gathered around a fire that night, talking among themselves after supper, when Reed came in to join them as his family and servants, in the adjacent rooms, prepared for bed. The conversation Reed had interrupted included an exchange between Joseph Lynch and Peter Quin, one of the *Warren* deserters, on the propriety of stealing Reed's gold. Quin decided it was wrong, Lynch said, and he agreed. Quin then asked Lynch to try to talk the others out of the robbery they were planning, but Lynch demurred. He didn't want them angry with him.

Lynch then described what happened next:

> *Barnberry was standing behind Read* [sic] *cutting some sticks, with an axe that he had in his hand, to throw on the fire. He stepped towards the fire and threw the sticks on, and then walked back again behind Read—I was at this time filling my pipe. I told Quin to give me a coal of fire. Just as he was giving me the fire I hear a blow of an axe struck by this man Barnberry on Mr. Read—he struck him on the head. Read fell and after he had fallen Barnberry struck him several more blows with the axe. After this the Indian stabbed Read with a knife. Quin and myself ran out after this in the corridor, and Mike* [Peter Raymond's assumed name] *and Barnberry brought us back again, and shut the door then said I have struck the first blow and there is no backing out.*

Backing out is exactly what Peter Quin and the other *Warren* deserter, Peter Remer, wanted to do. Quin was terrified of Barnberry. Eight days later, as his fate was to be decided in an inquest by a panel of Spanish-speaking strangers, he was just as terrified. At first, Quin refused to say anything to the panel examining him but then changed his mind. His grudging declaration, unlike that of the slightly older men (Quin was twenty, Lynch twenty-eight and Remer twenty-one), wanders and contradicts itself

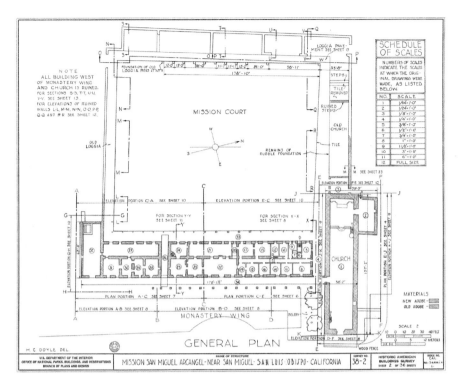

Floor plan of the mission, from a 1930s survey. The murder victims were buried in Area 2 of this drawing. *Library of Congress.*

so frequently that it's virtually unintelligible. Meanwhile, his shipmate Remer's testimony confirmed Lynch's story: Barnberry had struck the first blow, and the Indian, Juan, had then stabbed the helpless Reed. When Remer and Quin tried to leave the room, Barnberry threatened to "blow their brains out."

What happened in the next few minutes was even more horrific. With Reed dead, Raymond and Barnberry seemed to take the lead. Raymond evidently went into the quarters where two of the women were preparing for bed and ran them through with a cutlass; he then killed two children who were cowering under a bed. Barnberry killed the Reeds' cook with the axe; either Raymond and Barnberry or Raymond and Lynch emptied both barrels of a shotgun into the sleeping Indian shepherd who worked for Reed. Finally, Barnberry carried a child out of the quarters, protesting that he couldn't kill someone so young. Remer said that Juan killed the child with the axe; Lynch said it was Remer who did the killing.

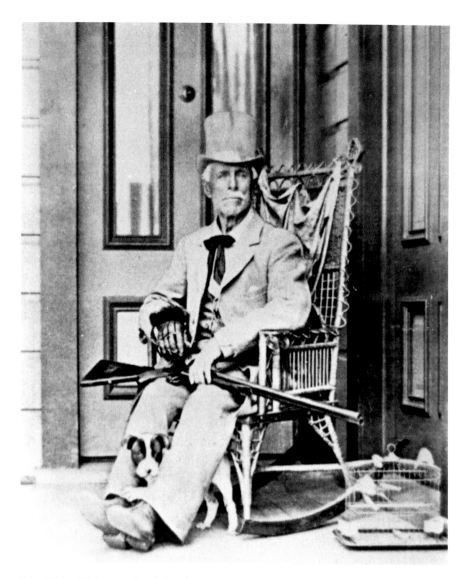

John Michael Price was the *alcalde* who helped to sound the alarm after finding the murder victims. *South County Historical Society.*

The killing had just ended when Beckwourth arrived, exploring hesitantly with a candle and a pistol and then galloping away at full speed for the nearest ranch. By the time he and about fifteen vaqueros returned, the killers had placed the bodies of their ten victims in the carpenter's shop and set them alight, but the fire had gone out. The murderers then set out on the

road but stopped a few miles away from the mission. Barnberry called the halt to divide what they had taken from the Reeds: it amounted to about $130 per man. With that business transacted, the killers headed south.

Meanwhile, Beckwourth, riding fast, headed north. When he reached the Monterey headquarters for the Tenth Military District, at the Presidio, he blurted out the news in a rush to the military governor's adjutant, Lieutenant William Tecumseh Sherman. "Leftenant, they killed them all, not sparing even the baby!" Sherman took the news to military governor Richard B. Mason, and Mason in turn sent Lieutenant Edward O.C. Ord of the Third U.S. Artillery and a small detachment of men on the road south toward San Miguel. Meanwhile, as Ord was starting out, rancheros John Price and Francis Branch, returning from the gold country, stopped at the mission and found the bodies still stacked in the carpentry shop. A deeply disturbed Price—he later told Ord that he could not sleep for three nights after finding the Reeds and their servants—sent a message south, written in a combination of English and Spanish, to his friend William Dana at Rancho Nipomo, warning him to be on the lookout; he also sent a representative, Trifón Garcia, on a hard ride of over a hundred miles to alert the authorities in Santa Barbara that the killers might be headed their way.

Back at San Miguel, a party led by William Reed's business partner, Petronilo Rios, buried the ten victims—eleven, counting Mrs. Reed's soon-to-be-born baby—in a common grave near the doorway of the sacristy, the priests' vesting room at the rear of the church.

When Trifón Garcia headed toward Rancho Nipomo, the killers were camped on his father's Rancho Atascadero. They then traveled, somewhat carelessly, by stages toward the south. Juan deserted the other five somewhere south of San Luis Obispo. In Los Alamos, they shot a calf and then panicked when a party of vaqueros rode past, thinking the cowboys had come after them for poaching the calf. They then moved toward Dos Pueblos, bought four horses there and then stayed overnight just south of Santa Barbara. They had just taken lunch and bought two bottles of *aguardiente* at another ranch when they spotted a party of about fifteen horsemen in pursuit.

It was a Santa Barbara posse led by ranchero Cesario Lataillade, and the pursuers had already missed a chance at intercepting the killers at an ambush spot that morning, so they were not in a compromising mood. Neither were the killers in the mood to surrender. When the two groups of horsemen met on the beach at Summerland, posse member Ramon Rodriguez and the fugitive sailor Barnberry fired at each other simultaneously and at virtually point-blank range. Both men fell dead. Raymond, the other man implicated

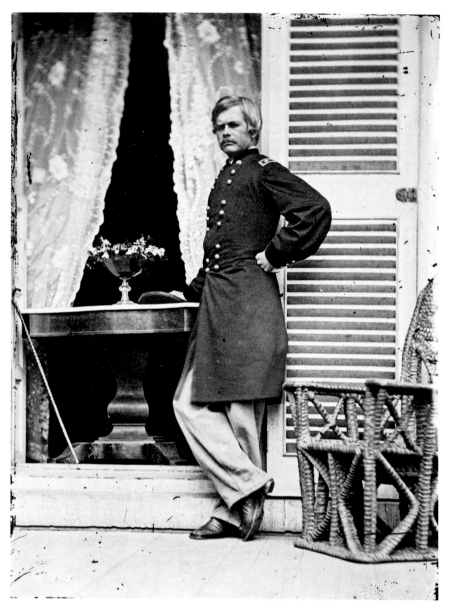

Edward O.C. Ord as a Civil War general. As a young lieutenant, he had commanded the firing squad at Santa Barbara. *Library of Congress.*

in the worst of the San Miguel murders, inexplicably dove into the breakers and began to swim out to sea while the posse opened fire on him. He started to return to shore, went under and disappeared. Both Barnberry's body and Raymond's, which later washed ashore, were left unburied on the beach.

Joseph Lynch, Peter Remer and Peter Quin would be given the Last Rites days after they'd given their statements. With Lieutenant Ord's detachment on hand, the Santa Barbarans who made up the ad hoc jury sentenced the three to be executed by a firing squad made up of his nine soldiers. The sentence was carried out in the late morning of December 28, 1848, near the intersection of today's Chapala and de la Guerra Streets. The three young men were buried at Mission Santa Barbara, a little more than three weeks after their journey together had begun at Mission Soledad.

A volley of letters between military governor Mason and Lieutenant Ord followed the firing squad. It was a heated bureaucratic squabble, but it was indicative of the tenuous nature of governing California. Young Ord had authorized the firing squad in writing in Mason's name, impetuously and in bold handwriting in the margins of the Santa Barbara panel's record of the death sentence. Mason hotly informed Ord that he had no such authorization, let alone in the colonel's name, and had exceeded his orders. The men had been found guilty by Californio civilians, Mason argued, and it was only appropriate that the death penalty be carried out by the men who had ordered it. Ord defended his actions as both expedient and necessary and demanded a court of inquiry to clear his name. That threat, and its attendant paperwork and embarrassment, was enough to force Mason to back down on the censure of his young subordinate, and the argument ended. Within a little less than two years, California would be admitted to the Union, but establishing law and order in the vastness of the thinly populated state—and in the one densely populated place in it, the Gold Country—would prove difficult.

3

MURIETA'S HEAD

T he Americans who flocked to the diggings—perhaps ninety thousand in 1849 alone—took up gold mining with the comforting belief that they deserved what gold there was to be mined. This attitude, of course, overlooked the fact that the Californios, whether of Mexican descent, like Petronilo Rios, or English, like John Michael Price, were, in fact, Americans now as well, thanks to the 1848 Treaty of Guadalupe Hidalgo. That distinction was lost on this Sacramento editorial writer in 1852:

> *Content with his herds of horses and cattle, his miserable adobe hovel, a few silver trappings of horse furniture, and a gaily adorned serape, the Alta Californian has existed for generations, without making one step towards the improvement of his own condition, or the development of his country's exhaustless resources. The immense deposits of gold hidden but a few inches below the surface of the earth upon which he trod, has laid there for ages, and might have remained concealed forever, had its discovery depended upon his industry to exhume it. With all the cupidity which enters so largely into the Spanish character, he was in ignorance of its existence, and left to other and a more enterprising people, the possession of a secret which his forefathers risked so much to obtain....It appears to be a fixed law in God's sublime economy, that the earth shall be occupied by those who understand and appropriate it to its intended uses.*

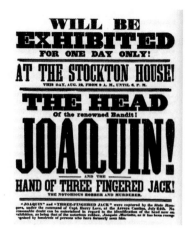

WILL BE EXHIBITED
FOR ONE DAY ONLY!
AT THE STOCKTON HOUSE!
THIS DAY, AUG. 19, FROM 9 A. M, UNTIL 6, P. M.

THE HEAD
Of the renowned Bandit!

JOAQUIN!
——— AND THE ———
HAND OF THREE FINGERED JACK!
THE NOTORIOUS ROBBER AND MURDERER.

"JOAQUIN" and "THREE-FINGERED JACK" were captured by the State Rangers, under the command of Capt. Harry Love, at the Arroyo Cantua, July 25th. No reasonable doubt can be entertained in regard to the identification of the head now on exhibition, as being that of the notorious robber, Joaquin Murietta, as it has been recognized by hundreds of persons who have formerly seen him.

Poster publicizing the exhibition of the head of the man alleged to be Joaquin Murieta. *Wikimedia.*

So those who were intended to carry out that "fixed law" were English-speaking Americans; Spanish-speakers—whether Californio, Mexican or the thousands of Chilean immigrants beginning to arrive in California—were not. Manifest Destiny began to manifest itself in the gold fields with attacks on "foreign" miners. Among the victims were Californios, some of the first to seek gold, and they did so with an energy that belied the Sacramento editorial.

Antonio Coronel, a schoolteacher and the future mayor of Los Angeles, was one of them. Historian Leonard Pitt notes that in that first year, Coronel mined enough gold to finance the land purchases that would begin to make him a wealthy man. But when he returned to the mines in 1849, everything had changed. Coronel and his friends encountered signs posted warning "foreigners" to keep out. He then witnessed what may have been the Gold Rush's first lynchings, in Hangtown (later Placerville), of a Frenchman and a Chilean. After moving farther north and hopefully out of harm's way, Coronel and some friends were met by one hundred Anglo miners who informed them that they had no "right" to prospect for gold along their riverbed. Coronel, as many Californios did in the summer of 1849, left the gold fields, never to return.

Legendary outlaws—what the Marxist historian Eric Hobsbawm called "primitive rebels"—are remembered because they have a backstory. Jesse James was allegedly avenging the South's defeat in Missouri, where the Civil War was intensely personal, literally pitting neighbor against neighbor, and vicious, obeying no known rules of war. William Bonney, or Billy the Kid, was redeemed in popular memory because he fought to avenge, in the Lincoln County War, the death John of Tunstall, allegedly a kind of surrogate father. Salomon Pico's origins are in the Gold Rush, and the outlaw who would terrorize El Camino Real from the Salinas Valley to Santa Barbara had the kind of appeal irresistible to romantic

Douglas Fairbanks in the 1920 film *The Mark of Zorro. Orange County Archives.*

novelists: he was from one of the wealthiest and most prominent families in California. A newspaper reporter named Johnston McCulley recognized the literary promise of an outlaw like Pico and borrowed elements from his life, transported him to Spanish California and gave him a new identity. He was Zorro, the character who first appeared in 1919 in a serialized novel in the pulp magazine *All Story Weekly.*

Pico's alter ego, Don Diego Vega, proved irresistible to both readers and writers. Chilean writer Isabel Allende updated the story in a bestselling 2005 novel. A series of dashing actors, including Douglas Fairbanks, Tyrone Power and Antonio Banderas, portrayed the outlaw who defends the poor from rapacious Spanish authorities in popular Hollywood films, and baby boomers grew up with Guy Williams's Zorro in the Disney television version. Zorro, among his other qualities, has staying power.

Pico's career was brief, but like the fictional Diego Vega, Pico was born into a privileged family, in San Juan Bautista. He was a Californio, and relations included Pio Pico, the last Mexican governor of California, and Andres Pico, the commander of the Los Angeles military garrison during

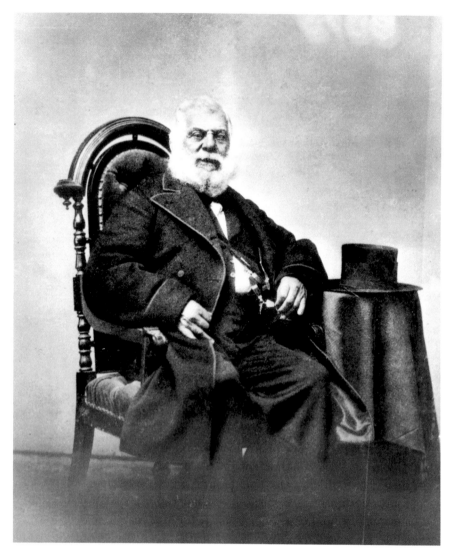

The titular head of the powerful Pico family was Pio Pico, the last Mexican governor of California. *Library of Congress.*

the Mexican War. Allegedly, Salomon Pico's life was destroyed when miners overran his ranch along the Tuolumne River. Some of them, according to the stories, brought the disease that killed his wife, Juana. So, like Jesse James and Billy the Kid, Salomon Pico, as his legend had it, had reason to declare a personal war on the newcomers he considered his enemies, and he fought his war along El Camino Real, today's Highway 101.

The leading San Luis Obispo County historian, Dan Krieger, writes of a newly nominated state senator, San Luis Obispo County prosecutor William Graves, riding south to Santa Barbara along El Camino Real in 1855 to make a campaign appearance; along the way, he frequently pointed out to his riding companion from Arroyo Grande, David Newsom, sites where the bodies of cattle buyers or, in one case, the bodies of an entire family, all murder victims, had been found in the recent past. Many apparently died in Drum Canyon, near Los Alamos, a site Pico chose to ambush travelers and where, some said, he would cut off his victims' ears to keep a tally of his killings. He may have spared young Juan Francisco Dana one day. The son of Rancho Nipomo's Captain Dana was riding to visit the de la Guerra family in Santa Barbara when he saw a horseman eyeing his own mount as he passed him on the road. Juan Francisco heard later that the man had asked about who the youthful *gringo* was who was so splendidly mounted. When Pico was told he'd seen a Dana, he nodded and said, "That's alright [*sic*]. I'd fight for Captain Dana's tribe any time."

If that was indeed Salomon Pico, then young Dana was lucky, because Pico, for once, demonstrated a shred of Zorro's gallantry. His time on the central coast came to an end after he narrowly escaped death in 1851. Pico was arrested for horse stealing and for the murder of a Monterey County mail carrier; the intercession of powerful men gained him his freedom. His partner, an outlaw named William Otis Hall, was not so lucky. After escaping from jail, Hall was captured and remanded to the town marshal's custody in Monterey where, in August, a "party unknown" overpowered the marshal, bound and gagged him and used a *riata* to garrote the outlaw in his cell. Pico moved to Los Angeles and then to Baja California, where, in May 1860, a firing squad may have executed him, along with several other bandits, in a roundup ordered by the governor there. If so, it was an ignominious end to an outlaw who seemed to be a cold killer, not a masked avenger of wronged Californios.

The Gold Country miner's name was Joseph Cannon, and he was just that subtle. He was a big man, over six feet tall and 230 pounds. On July 4, 1851, even though Cannon was an Australian, he decided that every miner in Downieville, California, needed to celebrate Independence Day with him. So the big man began pounding on the cabin doors, causing them to shudder,

since they were held gingerly in place by wooden latches and leather hinges. The inevitable happened: he broke down the door of a cabin, one belonging to a young couple who occupied a precarious place in Downieville's social order. The cabin belonged to José, a gambler. He and his kind were seen as parasites, and they were a bit too well dressed and smooth-talking for the rough-and-tumble miners. His lover, or common-law wife, was a prostitute named Juanita. José and Juanita were Mexicans, and that, too, made them vulnerable in a place like Downieville.

Meanwhile, Cannon, either despite or because of his boisterous nature, was a popular man. But he compounded his error by knocking down the cabin door and then falling with it, tumbling into the private space of the horrified young couple. In a society where order was based on the respect of property rights, Cannon was the most egregious of trespassers. A drinking companion righted the big man and pushed him back outside.

It was José who took up the issue of the broken door the next day when he confronted a reasonably sober Cannon. The conversation between the

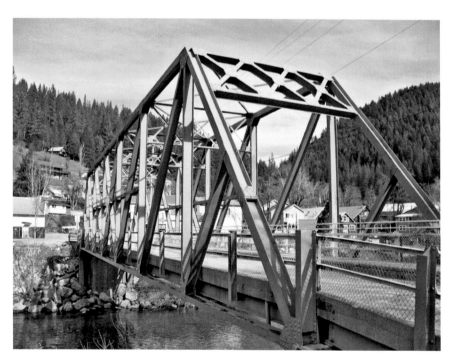

This Durgan Street Bridge, built in 1938, spans the North Yuba River at the site for Juanita's lynching, in 1851, from an earlier bridge. *California State Office of Historic Preservation.*

two began amicably, some said, but soon grew heated, bilingual and profane as the massive Cannon began to jaw at point-blank range with the smaller gambler. That's when Juanita, perhaps out of protectiveness, joined the argument. Cannon called her a whore. Juanita raised the ante with a bowie knife. She killed Joseph Cannon with it.

A platform had been erected in the settlement for the Fourth of July observance, and it now became the stage for an extemporaneous murder trial as five thousand enraged miners crowded around it, howling for Juanita's execution. They got it, and promptly, despite the intervention of a local doctor, who maintained that Juanita was pregnant. The crowd nearly turned on him, too.

Juanita was perhaps the calmest person in Downieville on July 5, 1851. She carefully climbed a ladder, along with an executioner, to a noose suspended from the crossbeams of the Durgan Street Bridge. She told the men below her that she would do the same thing again had any of them insulted her honor the way that Cannon had. The last thing she did was to free a braid of her hair from the noose before it was cinched tight.

Juanita's full name was lost to history. This was not the case for her countryman, a Sonoran, Joaquin Murieta, who would become an outlaw whose vast territory included San Luis Obispo County. Juan Francisco Dana remembered, when he was eleven years old, streams of Sonoran forty-niners crossing his father's Rancho Nipomo, mounted sometimes on horses, more often on burros and most often walking, on their way to the gold fields. They would sometimes camp overnight along a nearby creek, where Juan remembered them singing, sometimes accompanied by a guitar; he remembered most of all the pet parrot kept by one of the migrants, whose favorite phrase was "I want tortillas!" The Sonorans frequently bought milk from Captain Dana to make the gruel, *piñole*, that was their staple on the trip north. Dana, as was his custom, welcomed the travelers.

That wouldn't be the case once the Sonorans had reached the diggings in Northern California. As the number of miners increased, reaching 100,000 at its height, the amity that had characterized the Gold Rush in 1848 began to break down, and frequently the fractures were along ethnic lines. The Mexicans who now joined the American prospectors

were problematic in that they represented skilled competition; many had experience in Mexican mines, and it began to show. Historian Leonard Pitt described the Sonorans' prowess:

> *Where water was scarce* [for panning gold] *and quartz plentiful, as in the southern mines, they had the endurance to sit for hours and winnow dirt in their serapes....They could also improvise the* arastra *(mill), consisting of a mule harnessed to a long spoke treading in a circle and grinding ore under a heavy, flat boulder. Others eventually caught on to these techniques and machines and later surpassed them, but the Sonorans' sixth sense for finding gold and their willingness to endure physical hardship gave them great advantages. Talent made them conspicuously "lucky"—and, therefore, subject to attack by jealous Yankees.*

In the spring and summer of 1849, organized groups of Yankees began evicting not just Californio miners but also the new arrivals from Sonora, China and Chile. So many of the latter came to California that a neighborhood called Chiletown emerged on San Francisco's Telegraph Hill. In July 1849, the Hounds, essentially a street gang made up of military deserters, Mexican War veterans and Australians, nicknamed "Sydney Ducks," went on a drunken rampage in Chiletown, attacking the residents and burning their tents and businesses; one of the Hounds shot two Chileños, killing one. The citizens of San Francisco reacted with outrage, taking up a subscription for the immigrants whose property had been damaged, and many of the Hounds were banished from San Francisco, a necessary expedient in a boomtown that still lacked a jail large enough to secure so many lawbreakers. Similar outbreaks occurred in the mining camps. With statehood, legal sanctions began to supplement mob violence. An 1850 bill created a Foreign Miners' Tax aimed, transparently, at making mining for gold cost-prohibitive for Spanish-speaking and Chinese immigrants.

It is at about this time that an outlaw named Joaquin Murieta reputedly came from Sonora to California, and like Salomon Pico, he would become the subject of a series of imaginative biographies, the first version written by John Rollin Ridge in 1854. Ridge gathered stories about the outlaw, embellished them and, as Johnston McCulley had done with the Californio Salomon Pico, created a mythical figure in *The Life and Adventures of Joaquin Murieta*. Ridge's book established Murieta as a Mexican Robin Hood, cruelly wronged and determined to exact

revenge on the Americans. Ireneo Paz published a second version of the Murieta story in 1904 and places him on the Stanislaus River, where he is confronted by Yankees who order him off his claim and pistol-whip him when he resists. While Joaquin lay unconscious, the claim-jumpers rape and murder his wife, Carmen; when he comes to, Joaquin finds Carmen dead and the gringos gone. This begins a life of crime devoted to exacting justice from the hated Americans.

Murieta's outlaw career was brief and incredibly violent, but the violence was far more promiscuous than that carried out, in the name of justice, by the fictionalized outlaw created by Ridge and Paz. In the fall of 1851, Murieta threw in with a brother-in-law, Claudio Feliz, leader of a gang of horse thieves who raided ranches and killed travelers for their gold. When Feliz was jailed, Murieta took over the gang and expanded its territory far beyond the Gold Country, as far south as Los Angeles. Miners would be the Murieta gang's favorite targets—whether they be Americans, Chinese or Latino—a contradiction to the literary portrayal of a wronged Sonoran avenging himself on gringos. In early 1853, the gang began a two-month bloodbath, killing Chinese miners at Yaqui Camp and two Americans nearby, fighting a running gun battle with a posse and escaping to kill two more Chinese miners at Angels Camp and three Americans at French Camp before turning north. They then began raiding camps in Amador County. The gang escaped a second posse before pausing to regroup in Hornitos, in Mariposa County. In 1853, Murieta not only left behind a trail of murder victims but also a scattering of wounded gang members who were summarily lynched by frustrated posses in hot, but futile, pursuit.

So lurid newspaper accounts had already made Murieta famous in the spring of 1853 when he came to San Luis Obispo, according to newspaper reporter Annie Stringfellow Morrison's 1917 history of the county. The outlaw, in Morrison's account, announced his 1853 visit beforehand. He and his gang—"a swarthy set, armed to the teeth"—warned any gringos to stay out of their way, and they evidently did, remaining in hiding for the duration of the gang's stay. Murieta and his men camped out in the mission gardens and left after robbing only one local, a gambler, and this was a crime that offended nobody in the little town.

In a story by one-time San Luis Obispo County resident Charles L. Seeley, retold by folklorist Louise Clark, Murieta's acquaintance with San Luis Obispo went well beyond one visit. Seeley maintained, according to local tradition, that Murieta's mother lived on Chorro Street. The bandit

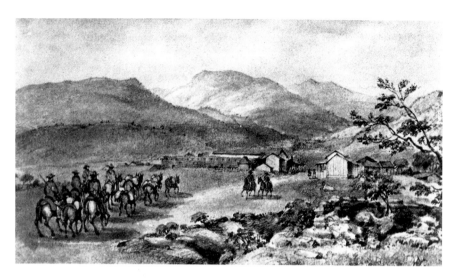

Riders, prudently traveling in a large group, approach San Luis Obispo in this 1860s drawing by Edward Vischer. *University of Southern California Libraries/California State Historical Society.*

was very fond of her and of visiting her, and when he did, he was the master of the place:

> *When he came into town, the place was his, that's all. Everybody just turned host—the sheriff's office, the alcaldes, and everybody else. He just did as he pleased. If he wanted to put his horse into a saloon, he'd just ride in with his men, line up at the bar, order the barkeep outside the bar to drink with the rest of them, and put his own man back there to tend the bar. When he got through, and everybody had had a good time, why, if they'd choose to break the necks of all the bottles and smash all the glasses, well, that was part of the performance. If nobody objected, Joaquin would pay the bill. Everything would be fine. But if anybody wanted to put up a fuss about it and wanted to fight about it, well, they got it, that's all.*

The good citizens of San Luis Obispo may have been far more willing to put up a fuss than Seeley thought. Historian Dan Krieger offers a different version of the local response to the outlaw, and it was neither friendly nor timid. Murieta reputedly made the Estrella district, near Paso Robles, a place for his outlaw gang to rendezvous. Whenever word of Murieta's presence

nearby reached the county seat, the reaction was swift. Men would descend on the Casa Grande, a meeting place and courthouse near the mission, and a heavily armed posse would emerge to search for the elusive bandit. One of those posses, led by future governor Romualdo Pacheco, arrested seven men in the Edna Valley after a chase that was marked by daring, especially on Pacheco's part. The posse's captain coolly walked into the light of the campfire and announced to the horse thieves that they were in his custody. The trip back to San Luis Obispo, the first leg of their journey to the state penitentiary, was marked by good-natured bantering among posse members and felons alike. If enforcing the law was primitive in an isolated county like San Luis Obispo, this incident reveals the willingness of citizens to take that responsibility on, even given the chance that any outlaw they encountered might be Joaquin.

That was part of the problem. Any outlaw a California posse encountered might well *be* Joaquin; there may have been as many as five bandits using that name in 1853. Murieta himself may have sometimes used his natural father's surname, Carrillo, and one of Murieta's gang members was Joaquin Valenzuela. The confusion magnified the fear generated by the gang and their leader, who was sometimes accused of simultaneous crimes committed several hundred miles apart.

Murieta finally went too far when his gang murdered a harmless farmer, Allen Ruddle, on the road to Stockton. Ruddle's family offered a reward, and the state authorized the formation of the California Rangers, a twenty-man team led by a tough lawman and Mexican War veteran, Harry Love, "ornery, fearless, deadly, and always well-armed… [with] a .44 Colt Dragoon." His Irish-born deputy, Patrick Connor, was no softer; as a Union general in the 1865 Powder River Expedition, Connor's standing orders were to kill every male Cheyenne and Sioux over the age of twelve.

After riding down the state, killing one gang member in what is today Thousand Oaks, Love and the rangers finally caught up with Murieta and seven gang members in July 1853 in their camp near Coalinga. In an exchange of gunshots, the rangers killed at least two men. They identified one of them as Murieta, another as a gang member nicknamed "Three-Fingered Jack." The putative Murieta was decapitated as evidence of his death. Once Murieta's head—and Jack's distinctive hand—were removed, they were put into gunny sacks for transport to Fort Miller, in Fresno County, where, rapidly deteriorating in the San Joaquin Valley's summer heat, they were transferred to jars of alcohol for preservation. Love used

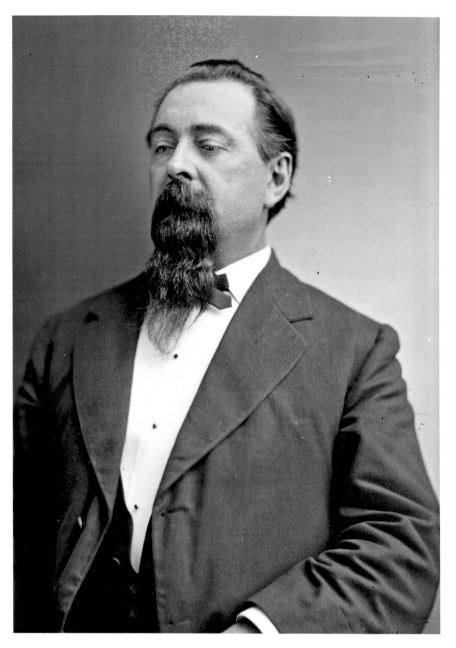

Romualdo Pacheco, who would become California's governor, was a stepson of North Coast *ranchero* Captain John Wilson. *Library of Congress.*

A Colt Dragoon revolver, the weapon of choice for California Ranger Harry Love. *Courtesy Hmaag/Wikimedia Commons.*

the grisly evidence to gather seventeen affidavits testifying to the trophies' identities. The ultimate result, for him, would be a $1,000 reward from the governor and a princely $5,000 bonus from the state legislature.

Murieta's jar would make the rounds of Northern California towns, where gawkers paid a dollar to face the outlaw eye-to-eye. Eventually, the jar and its sad contents would disappear in the 1906 San Francisco earthquake. Like Salomon Pico, Murieta would be idealized in books, *corridos* and a host of Hollywood B films, so he would not disappear so easily—neither would crime in San Luis Obispo County. By the mid-1850s, the region was the most murderous in America, and local citizens would begin to take the law into their own hands.

4

THE VIGILANCE COMMITTEE

We are helpless. At an election, or at the empanelling of a jury, it is very easy for an unwashed greaser to swear that he came to this county before the treaty with Mexico. That oath makes him a citizen, and he takes his seat in the jury-box. The Frenchman, the Englishman, the Irishman can't do this. His conscience won't permit it. Therefore, although the good men of this community are in the ascendancy, as far as numerical strength and acknowledged respectability are concerned, yet at the ballot-box and in the jury-room they are powerless.

—*Walter Murray, attorney, writing on the difficulty of obtaining a criminal conviction in San Luis Obispo County during the 1850s*

Two things would seem immediately apparent from this passage: Walter Murray was frustrated, and he was a racist. However, the truth, as it always is, is much more complex and elusive. Murray came to San Luis Obispo from the Gold Rush town named after the place of origin of so many Mexican miners: Sonora. And he had married a Latina. His wife, Mercedes Espinosa, a widow, had been born in Chile. Indeed, many of the men who might have agreed with Murray's view were Californios, men of Mexican descent, but they were *ricos*—rich men. They were also ambitious men, like Murray. By 1858, San Luis Obispo County had become so violent that both newcomers and Californios participated in forming a vigilance committee, perhaps modeled on the far more famous one in 1856 San Francisco. Local citizens, however, worked more assiduously, for while

the people of San Francisco hanged only four men, their San Luis Obispo counterparts, in a far smaller town, hanged at least six. A similarity in both committees may be that their motivation was a determination not only to contain crime but also to fundamentally shift the locus of political power.

There is ample statistical evidence of racism in the behavior of lynch mobs and vigilance committees in the American West. Of California lynchings documented between 1849 and 1902, 50 percent of the victims were "nonwhite," by nineteenth-century standards—Latinos, Chinese or African American—while ninety percent of the lynched suspects' victims were white. In 1858, the year San Luis Obispo County's vigilance committee was formed and carried out its campaign against outlaws, six men were hanged and one shot and they were all Latino. However, if the pattern of racism is obvious, it doesn't go far enough to explain San Luis Obispo County's reaction to the criminal gang that terrorized the region.

The gang's nemesis, newspaper publisher and jurist Walter Murray, was born in London, England. The gang's leader, Jack Powers, was not Latino; he had been born in Ireland. Both Murray and Powers had come to California during the Mexican War as soldiers in the First New

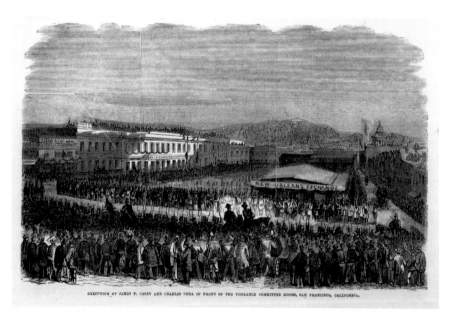

The lynchings of Casey and Cora outside the vigilance committee headquarters, San Francisco, 1856. *Library of Congress.*

Documentary photographer Jacob Riis captured the squalor of Manhattan's Hell's Kitchen forty years after Jack Powers had lived there. *Library of Congress.*

York Volunteers, a regiment whose recruitment into military service was sweetened by the promise of California land once the war with Mexico was won. Upon their arrival here, Murray's and Powers's lives took very different directions.

Ironically, if anyone had the potential to fit the role of a swashbuckling character like Zorro, it was Jack Powers. After his family arrived in America, he spent his adolescence in tough, gang-infested neighborhoods like Hell's Kitchen and the Bowery in Manhattan. This is where he learned the survival skills he would put to use later. During the Mexican War, his company of volunteers, stationed in Santa Barbara, was a rowdy one, barely under the control of its captain. The twenty-one-year-old Powers quickly made himself at home. He was handsome, charismatic and a graceful dancer, which immediately endeared him to Santa Barbara's women. Also, like so many Irish, he loved horses, and he was a superb horseman, which immediately endeared him to Santa Barbara's men,

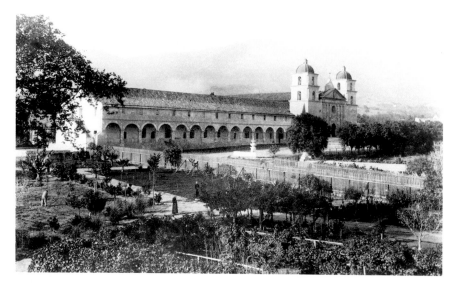

Jack Powers and his gang sometimes used Mission Santa Barbara, seen here in 1890, as their headquarters. *Library of Congress.*

who—like the Irish—were enthusiastic bettors, especially on horse races. This is where Powers established his reputation as a gambler, willing, ultimately, to make one of his biggest bets on himself. The greatest race of his life would come in May 1858, when he won a $5,000 wager that, provided ample relays of fast horses, he could cover 150 miles in under eight hours at San Francisco's Pioneer Race Course. He did it in six hours and forty-three minutes in front of an estimated ten thousand spectators, or one out of every six inhabitants of the city. Powers had insisted on personally choosing his mounts, all California mustangs, and on choosing the vaqueros who would handle them during the race, Pio Linares and Rafael Herrada, who was nicknamed "*El Huero*" (a blond or fair-complexioned man).

Within days, the three men would be implicated in murders near Shandon, in San Luis Obispo County.

San Luis Obispo County already had a violent reputation when twenty-seven-year-old Walter Murray moved there in 1853. This is where he and his wife would raise a family that would eventually include five children. At the time, the town seemed to be no place to start a family, as suggested in a report from San Luis Obispo that appeared in the *New York Times* of November 29, 1853. A man described as "a Sonoran," Bernardo Daniel, was found in possession of silk identified as belonging to two peddlers who had recently been murdered on the Cuesta Pass. When the sheriff at the time, probably Alfred Mann, attempted to put Daniel into a cell in the jail, then at the end of the mission colonnade, his prisoner broke free and sprinted toward San Luis Mountain with locals chasing him, "firing their pistols off at random." They caught him, held an impromptu trial and, a ten o'clock that night, pulled him out of his cell and hanged him from the joist of the jail. Three more suspects in the peddlers' murders were arrested in Los Angeles, put on the steam tug *Goliah* north to Port Harford

An 1876 panorama of San Luis Obispo reveals how sparsely populated the town was even twenty years after the vigilance committee. The steeple of St. Stephen's Episcopal Church, which still stands on Nipomo Street, is at right. *Wikimedia.*

and, once ashore, at today's Avila Beach, hanged almost immediately from the nearest tree. The *Times* correspondent hints at one more hanging in ending his account on a somewhat triumphant note: "Thus died the fifth huge scoundrel that has been executed by our citizens exemplarily, within the last two weeks."

The writer of the account signs it only with the initial "W."

Walter Murray, who would eventually found the *San Luis Obispo Tribune*, came from a background just as humble as Jack Powers's. He clerked in London law courts before winning a lottery that brought him to America. He became a compositor at printers' shops in Boston and New York, where he joined the New York Volunteers during the Mexican War. During his turn in the gold fields, where he started the *Sonora Herald*, he befriended future California governor Romualdo Pacheco, and the two would continue their friendship in San Luis Obispo. Here, Murray applied successfully for the bar and began practicing law.

Murray's San Luis Obispo was overwhelmingly Californio—he argued cases in front of a difficult district judge, Joaquin Carrillo, who spoke only Spanish, and he grew increasingly frustrated by jury trials where, in his eyes, Californio defendants were inevitably exonerated by juries dominated by their peers. Adding to his frustration was the sense that Central California was less subject to the rule of law than to the terror generated by the gang of outlaws who had succeeded Salomon Pico after he'd left the area in 1851. Like Pico, these bandits left the road between Monterey and Santa Barbara littered with the remains of their victims—in San Luis Obispo County, with a population of under 1,800 people, there were eleven murders in 1855 alone. Their favorite targets were cattle buyers, who carried large amounts of gold or hard cash, and the fate of men who traveled along what had become an outlaw trail was a hard one. The motto of killers like Pico and the men who succeeded him was simple and brutal: "Dead men tell no tales."

Murray knew, as most San Luis Obispo residents knew, that the man who pulled the strings for the gang of killers was Santa Barbara's Jack Powers. But Powers himself, who had an informal alliance with Santa Barbara authorities and another with Los Alamos ranchero and horse breeder José Noriega y de la Guerra, eluded capture. He frequently turned up, ostentatiously shaking hands and pounding backs, in Santa Barbara saloons and billiard parlors within hours of the latest killing along El Camino Real. The rapidity of his appearance was his alibi, and it was one made possible by Don José's fast horses and by the same equestrian prowess Powers demonstrated at the Pioneer Course in San Francisco.

The Pio Linares adobe in the early 1900s. *Braun Research Library Collection, Autry Museum, Los Angeles; P.18162.*

Powers's lieutenant in San Luis Obispo, one of his "lookouts," was Pio Linares. Linares's father, Victor, was the original grantee of the Rancho Cañada de Los Osos, which he sold in 1844 to the Scots-born Captain John Wilson. The younger Linares lived in an adobe on today's Andrews Street and kept a small ranch. He was a tough young vaquero in his mid-twenties, "known to be handy with a knife and prone to taking part in saloon brawls." Walter Murray was convinced that Linares was much more than a barroom bully: he was a killer, and he killed at the command of Jack Powers.

Powers was nothing if not consistent, and it was his presence at yet another horse race in November 1857 that would link him and Pio Linares to a double murder. Another Powers associate, Nieves Robles, had sold a herd of cattle to two Northern Californians, Basque settlers named Pedro Obiesa and M. Graciano. Powers assembled his gang at the horse race, in Santa Margarita, and dispatched Robles to catch up with the two cattle buyers, evidently still flush with cash. It was Robles who guided the two hapless men, once he'd caught up to them, to a stopping place on the Nacimiento River,

and, on the morning of December 1, it was Linares and El Huero—the same men who would handle Powers's relay of horses the following May in San Francisco—who shot the two, evidently waiting for them on the road as they resumed their journey. Robles, Linares and El Huero made off with $3,500. Linares and Nieves Robles returned to San Luis Obispo, where the latter began spending freely and bragging about the killings. Three weeks later, the decomposing corpse of one of his victims was found with bullet holes in its skull. This, along with word of Robles's boasting, was enough evidence for Sheriff Francisco Castro; he interrupted Robles at a gaming table on Chorro Street and arrested him.

When word got to Powers, living high in San Francisco, about Robles's arrest, he caught the next steamer south. Upon arriving, he provided his friend with "coffee, liquor, and other comforts" in his dark jail cell in the mission colonnade. Powers quickly retained the best attorney he could find: Walter Murray, whom he may have known when both men served in Stevenson's Mexican War regiment. Murray went up against an accomplished prosecutor, William J. Graves, but he won the case. The jury let Robles go. Murray had won a victory that must have troubled him deeply. It must have only confirmed his suspicions that no prosecutor could convict a Californio in front of a Californio jury. His decision to reckon with men like his one-time client Nieves Robles would come in May, after another double murder.

Lynchings, like those that "W" reported in the *New York Times* in 1853, were spontaneous, organic and represented the darkest manifestation of Jacksonian democracy. Far too frequently during the nineteenth century the popular sovereignty of angry men replaced the rule of law. This was a common occurrence in Gold Rush California, where more formal institutions of law enforcement were in their infancy and, indeed, where the local jail might be so fragile that there are stories of escapes made when prisoners simply kicked out the jail's back wall. The Santa Barbara citizens' jury that had condemned the San Miguel Mission murderers represented a more sophisticated attempt to carry out the rule of law in a situation, in California before statehood, of uncertain jurisdiction. Vigilance committees, like those in 1856 San Francisco (an earlier committee had operated there in 1851) and in 1858 San Luis Obispo, pushed aside altogether the mechanisms of law enforcement, of both

Right: Walter Murray, newspaper publisher, vigilance committee leader, judge. *San Luis Obispo County History Center.*

Below: San Francisco's Portsmouth Square, 1851, with the offices of the newspaper the *Alta California* at center. *Library of Congress.*

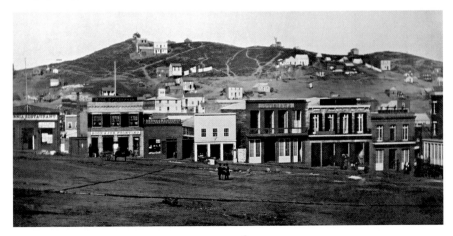

police and judicial authorities, and superimposed formal, if temporary institutions in a way that was revolutionary. If they shouldn't be confused with the revolutionary tribunals of France during the Terror, the vigilance committees nonetheless carried distinct political agendas.

San Francisco's committee would eventually adopt a political agenda, but its work began with the aim of avenging a murder. In 1856, newspaper editor James King of William was shot dead on Montgomery Street by San Francisco supervisor James Casey. King had dedicated himself to exposing the machine politics of David Broderick, a small-time San Francisco equivalent of New York City's Boss Tweed. King revealed in his news columns that Casey, a Broderick crony, had done time in Sing Sing, and the editor paid for that story with his life. When King, popular and widely read, died, the call for a vigilance committee to avenge him and to clean up the city quickly drew ten thousand men who formed an ad hoc militia. In May, the committee hanged Casey and another man, Charles Cora, from the rooftop of its headquarters on Sacramento Street. But what distinguished the San Francisco vigilantes from other movements was what came *after* the executions. The movement transformed itself into a political party, dedicated to ending corruption and to the promotion of effective government, that would dominate San Francisco politics for a decade.

Two years later, if San Luis Obispo's vigilance committee lacked the political cohesion of San Francisco's, it may still have represented a fundamental political shift in power, and there is no better symbol of that shift than lawyer-editor Walter Murray, one of the committee's founders. It may be significant that the first of Murray's five children was two years old in 1858. Her very presence signaled a change in San Luis Obispo society, and historian David A. Johnson notes a similar change in 1856 San Francisco:

> *The middle-class values of home and hearth attained hegemony over the male dominated gold rush society.... [A]s the dramatically skewed sex ratio began to change with the arrival of women and children, the values, power and moral authority of San Francisco's merchant middle class came into sharp conflict with the masculine democracy of the gold rush. In 1856 matters came to a head. San Franciscans arose in their wrath to purify their city and, most important, to assure its future purity through a political revolution.*

If Murray's frustration with the laxity of courts and juries in dealing with Californio lawbreakers reveals a streak of racism, this obscures the fact that he was a family man, a new father, and that the violent, masculine world

Paso Robles founder Daniel Blackburn was another leader of the vigilance committee. *San Luis Obispo County History Center.*

of men like Jack Powers and Pio Linares, for him, had to come to an end. San Luis Obispo was beginning to make the shift from the county seat of a "cow county" to a town that was, among other things, more conventionally "American." It was more middle class, a middle class that embraced the mid-Victorian cult of domesticity, in which women were assigned a special, if painfully constricted, role as nurturers and civilizers; it was more Protestant; and it was more business-oriented.

The list of men who made up the committee's executive board, the men who would authorize the death sentences of Jack Powers's followers, included rancheros and Californios. (62 of the 146 members of the larger vigilance committee had Latino surnames; others, like William C. Dana, had Californio mothers.) But the list also included Yankee businessmen: the developer of a commercial wharf, two future state assemblymen, two future judges, including Murray, and a lumberyard owner. At least four streets in San Luis Obispo—Murray, Price, Beebee and Graves—are named for members of the vigilance committee's executive board. Men like these would see to it that outlaws' saloons would be replaced by Masonic lodges and public schools.

<center>⁂</center>

It was the heart-rending story of a woman that sparked the formation of the vigilance committee. Her ordeal may have provoked the same chivalric instinct that motivated the Santa Barbara posse to chase down the killers of Mrs. Reed at Mission San Miguel. The woman's name was Andrea Baratie, and on May 12, 1858, she had watched in horror as a gunman murdered her husband at their ranch, near Shandon. After the fatal shot to Bartolo Baratie's head, his wife covered his face with his hat and his body with his coat. Mr. and Mrs. Baratie and their business partner, M. José Borel, had moved to San Luis Obispo County from Oakland only ten days before. The killers had spent the night before nearby after asking for and receiving a meal from the new ranchers. They were led by Pio Linares. Linares missed the killing the next day only because his horse threw him, and he gingerly made his way back to San Luis Obispo; it was Jack Powers's other Pioneer Course assistant, El Huero, who took charge of the seven horsemen who raided the ranch, shot Borel dead, took $2,700 from Baratie and then shot him. Finally, the gang, on their way back to San Luis Obispo, shot a farmer standing amid his crops. The farmer, Jack

The Wilson Adobe, Los Osos Valley. The Wilson *rancho* was the site for a two-day gunfight between vigilance committee members and the Linares gang. *Braun Research Library Collection, Autry Museum, Los Angeles; P.20313.*

Gilkey, had the misfortune of meeting the gang when they were on their way to the Borel-Baratie ranch, and the gang eliminated the potential witness with a bullet to the back of his skull. Linares had wanted Mrs. Baratie killed, as well, but one of the bandits instead took charge of her, mounted her on one of her husband's horses and led her on a meandering and harrowing five-day journey that ended with him dropping her off at the cabin of a shepherd. From there, she finally made her way to Oakland and told her story to the authorities.

By mid-May 1858, San Luis Obispo residents seem to have lost patience with the authorities. Soon after the double murder, one of the vaqueros who had worked at the Baratie-Borel ranch walked through town with Sheriff Francisco Castro and identified a man, Santos Peralta, as one of the gang of killers. Castro immediately arrested him, but a mob took Peralta from the jail that night and lynched him just outside. When Linares was reported to be at his *ranchita* near town, Castro deputized fifteen citizens, surrounded Linares's home and attempted to smoke him out during a gunfight. The outlaw escaped, and the bandit's escape may have been the impetus for the formation of the vigilance committee at Murray's ranch house just north of town, near the site of the Motel Inn. Linares himself evidently heard of the meeting, which also included Daniel D. Blackburn, a founder of Paso Robles. Linares led a gang of followers on an intended raid on the

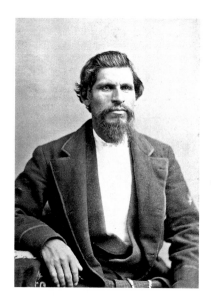

Outlaw Tiburcio Vasquez's grandfather owned over four thousand acres, Rancho San Luisito, between San Luis Obispo and Morro Bay. As he awaited the trial that would end with his death sentence, Vasquez sold photos like these to admirers from the windows of his jail cell. *Courtesy John Boessenecker.*

meeting—evidently, the 1858 equivalent of a drive-by shooting—but the gunmen apparently lost their nerve. Linares was furious, but the end of his career, and his life, was imminent.

Not only Linares's death but also those of several accused gang members followed with astonishing rapidity. On June 8, José Antonio Garcia and Luciano Tapia, the latter man the kidnapper of Mrs. Baratie, were hanged in what would become, in San Luis Obispo and throughout the West, a ritual as fixed as the *auto da fe*, the burning of heretics during the Spanish Inquisition. Once the suspects had given their confessions to the vigilance committee, their sentences were carried out in front of Mission San Luis Obispo. They were allowed a statement and the Last Rites, the noose was secured and then it is most likely that the support they were standing on—a barrel or a sawhorse—was kicked out from under them. It had to be a terrible way to die. Even with the most accomplished and professional of executioners, in 1875 San Jose, it took another famous outlaw, a man who also frequented San Luis Obispo County, Tiburcio Vasquez, at least eight minutes to die after the trap had been sprung and the noose had broken his neck. Vasquez died in front of paid ticketholders. Two of them, both men, fainted.

Linares escaped the noose only because a shepherd revealed his campsite in the Los Osos Valley, on ground familiar to the outlaw. He was hiding out on the vast rancho of John Wilson, who had bought Vicente Linares out in 1844. The vigilantes swarmed to the spot. In a two-day gun battle in dense oak scrub, Linares was killed by a rifle shot to the head. Two gang members, Miguel Blanco and Desiderio Grijalva, were captured, and they would be hanged in front of the mission. There was no escaping that fate because the gang had killed a citizen, John Matlock, during the gun battle that had also wounded Walter Murray in the arm. Matlock's funeral was a public one and especially somber, but it fell on a Sunday, so to observe

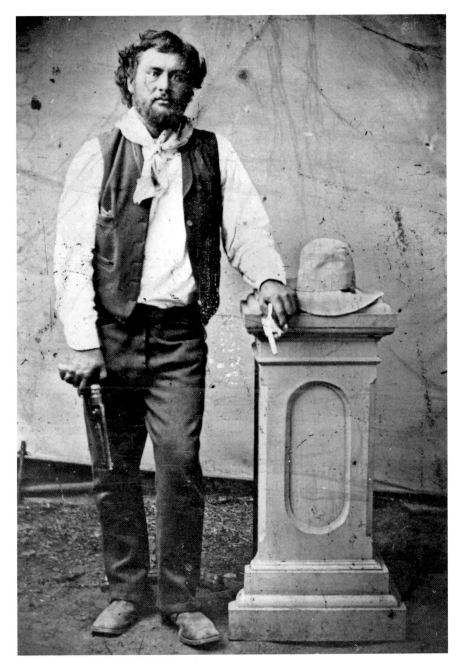

This image is reputed to be that of the outlaw Pio Linares. *San Luis Obispo County History Center.*

proprieties, the committee carried out the death sentence on Monday.

Two weeks later, the man whom Walter Murray had once represented in court, Nieves Robles, was hanged at the intersection that now separates Mission San Luis Obispo from the county historical museum. He'd been arrested in Los Angeles and was brought back to San Luis Obispo to die by Walter Murray's friend from the Gold Rush days in Sonora, Romualdo Pacheco, now a state senator. Two more gang members would elude capture: El Huero, Rafael Herrada, had somehow escaped the gunfight that killed Linares, and he disappeared. Jack Powers was last seen on a steamer bound for Mexico; he was probably shot there by another bandit two years later, in 1860. The two had quarreled over a woman. Powers lost. His body, some stories said, was dumped into an enclosure filled with hungry hogs.

The vigilance committee disbanded that fall. Shortly thereafter, Sheriff Castro submitted a handwritten request to the San Luis Obispo County Board of Supervisors:

Walter Murray's tombstone in the San Luis Obispo cemetery. *Photo by Rich Jordan.*

> *I beg leave to ask your attention to the condition of the county jail some two weeks since a vigilance committee broke it open the purpose of taking there from a prisoner there in custody. In so doing the front gate was broken in and the lock shattered to pieces, the front door was broken open and two cell locks destroyed. Consequently it is impracticable to secure a prisoners* [sic].

There would be two more Californio sheriffs after Francisco Castro. The surnames that follow are Irish, English or German. Walter Murray would succeed the irascible and monolingual district judge, Joaquin Carrillo. Murray would serve until his death at forty-nine in 1875, when he would be honored with one of San Luis Obispo's biggest funerals to date and taken to his rest by his Masonic brothers. The order's symbol is carved into his tombstone's base, and the tombstone offers one more clue that his wife and

family were the foremost priorities in his life: another carving shows a man's hand and a woman's clasped in a final goodbye.

Five years after the vigilance committee was disbanded, the rain stopped. Cattle all over the county littered hillsides with their bones. The terrible drought of 1863–64 meant that the days of the vaqueros were largely done. Californio cowboys were replaced by easterners, Civil War veterans who grew row crops or tree crops, or by immigrants, Swiss or Azorean immigrants who started dairy farms. All of them filled little rural schoolhouses with their children.

TIMELINE

San Luis Obispo Vigilance Committee

November 30, 1857	Powers and gang meet at Santa Margarita horse races.
December 1, 1857	Cattle buyers Obiera and Graciano are murdered.
December 20, 1857	Nieves Robles arrested, later acquitted, for the double murder.
May 2, 1858	"Great Race against Time," San Francisco.
May 12, 1858	Ranchers Borel and Baratie murdered, followed by farmer Jack Gilkey.
May 1858	Santos Peralta is lynched. Shootout between Linares and sheriff's posse occurs in San Luis Obispo. Vigilance committee is formed.
June 8, 1858	José Antonio Garcia and Luciano Tapia are hanged.
June 10–11, 1858	Linares is killed during a shootout in Los Osos; posse member John Matlock is also killed. Walter Murray is wounded.
June 13, 1858	Public funeral for Matlock.
June 14, 1858	Miguel Blanco and Desiderio Grijalva are hanged.
June 28, 1858	Nieves Robles is hanged.
September 1858	Vigilance committee disbands.

"PARTIES TO THIS JURY UNKNOWN"

Excerpt, *San Luis Obispo Tribune,* 1883:

County Correspondence
SANTA MANUELA SCHOOL

EDITOR TRIBUNE: *Following is a report of the Santa Manuela school for the month ending November 2nd, 1883. Total days attendance 299½; days absence 22 ½, whole number of pupils enrolled 19; average number belonging 15. Present during the month, Joe Branch, Julius Hemmi, Leroy Jatta, Charlie Kinney and Addie Hemmi.*

CLARA GANOUNG, *Teacher.*
Arroyo Grande, Nov. 3, 1883.

When the Lopez Dam was completed in the Upper Arroyo Grande Valley in 1968, San Luis Obispo County officials were hopeful that the lake intended to appear behind it might fill in five years. It filled in one. So much rain came in 1968–69—the opposite of the terrible 1860s drought—that the dam spilled in April. During the winter, Arroyo Grande Creek filled to twenty feet deep where it flowed under Harris Bridge, at the intersection of Huasna Road and today's Lopez Drive. School had to be canceled some days. With the high school built on top of hardpan in the floodplain of the Lower Valley, upperclassmen joked that the standing

The Santa Manuela schoolhouse, Arroyo Grande. *Photo by Elizabeth Gregory.*

waters were too deep for presumably shorter freshmen, who, luckily, attended a separate campus safely atop Crown Hill.

A wonderful example of historical foresight came before the dam's completion, when authorities moved the 1901 one-room Santa Manuela School away from what is now lake bottom. Today, moved again, it sits in Heritage Square, near the swinging bridge that spans the creek in downtown Arroyo Grande. It is a lovingly preserved and charming evocation of the kind of education that mattered most to turn-of-the-century farmers.

That meant, for students like Julius Hemmi, also known as P.J., the wisdom of the basics. P.J. would have been one of the bigger boys in an earlier Santa Manuela schoolhouse, taught in an even older version of the little school. There was no high school yet, so Hemmi's classroom days were ending. P.J., if he was attentive, would have mastered, by the time the 1883 notice appeared in the *Tribune*, his times tables and percents, his state and his European capitals, would be able to recite "The Gettysburg Address" and to write, for a boy, passable longhand. That was all that this thirteen-year-old boy would need to take up farming with his immigrant father, Peter. If P.J. was a big boy, and he

probably was, there is always the chance that he got to practice the kind of tyranny over his younger classmates depicted in novels like *Tom Brown's School Days*. But with nineteen students, a big boy like Julius would have been on Miss Ganoung's short leash. If she was typical of rural schoolmarms in the late nineteenth century, she kept that leash tight, protected the younger children and kept a small circle on her blackboard against which saucy students would press their noses, without moving, for an hour at a time.

P.J., though we don't know this, may not have needed the chalkboard circle at all, because the other names in the newspaper notice—Branch and Jatta, for example—belonged to families far more important and far more prosperous than the Hemmis were, so he might have accepted his place in the small social hierarchy of Lopez Canyon. Joseph Branch's grandparents were the first to settle the Arroyo Grande Valley, in 1837, and his grandfather had to contend with monstrous grizzly bears and Tulare Indian raids, vanquishing both threats. Leroy Jatta was the son of a Canadian immigrant, Joseph Jatta. Joseph, though a more recent arrival, would establish important connections through the marriage of a daughter, Clara, to the up-and-coming Loomis family. Progressive and community-minded settlers like the Jattas and the Loomises would form the foundation of Arroyo Grande's merchant class, and their heritage would be important to the valley deep into the twentieth-

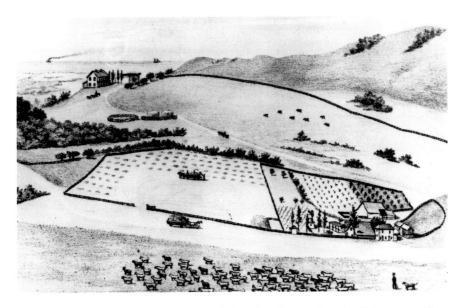

An idealized 1880s farm, in this case, John Price's, from Myron Angel's 1883 history of San Luis Obispo County. *South County Historical Society.*

first century. They were families known for their enterprise and, even more, for their integrity. We do know this much more about P.J.: he had a little sister, Addie, to look after at school, and he would always know that she was looking up at him. We know, too, that Mrs. Hemmi adored her son.

It was April Fool's Day 1886, so the teachers in town, at the two-story school that stood on the site of today's Ford agency in Arroyo Grande, would have refused to believe the ashen-faced boys that morning, as they ran into the Arroyo Grande Grammar School, blurting out their news even before they began the morning ritual of hanging their coats and hats on two tiers of brass hooks and placing below them their lunches, packed in tin boxes. These boys attended a school monstrously bigger than Santa Manuela. (The Arroyo Grande students would have seen Santa Manuela as a school for country hicks.) Since they were boys of the town, a little more sophisticated and a little more jaded than the children from the one- or two-room schools of the Upper Arroyo Grande Valley, Los Berros, Edna or Nipomo, no teacher with more than two years' experience would have believed for a moment any of them when they insisted that they'd seen two men hanged from the Pacific Coast Railway trestle at the upper end of town, just below Crown Hill. No teacher would have hesitated to rebuke a little boy with such a cruel April

The Pacific Coast Railway bridge at left was the site for the 1886 Hemmi lynchings in Arroyo Grande. In the distance is the two-story elementary school. *San Luis Obispo County History Center.*

Fool's joke, one so tasteless that it merited a circle on the blackboard or, even better—far better—a mouthful of powdered soap.

But the little boys weren't lying.

There *were* two men hanging from the Pacific Coast Railway trestle, and they would remain there until the coroner drove down that afternoon from San Luis Obispo, stared up at them and then testily convened a work party to cut them down that then doubled as his inquest jury. One of the bodies belonged to Addie Hemmi's big brother.

P.J. was fifteen years old when the good citizens of Arroyo Grande lynched him from the little railroad bridge over the Arroyo Grande Creek, an incident shocking in many ways, but in part because of its timing: it was four decades after the Gold Rush, yet the justice of what the miners had called "Judge Lynch" was very much alive, unlike Peter Julius Hemmi. He would have been as stiff as a dead mule deer by the time the awed little third graders found him the morning of April Fool's Day. A buck's death was the only kind of death these little boys might ever have seen, a death dealt at the hands of their fathers. Above the empty stiffness of his body, P.J.'s face would have been the color of clay. His father, Peter, was hanging next to him. For the time being, the best conclusion that the coroner's inquest could provide was that the two had died at the hands of "parties to this jury unknown." The little boys on their way to school who had found the bodies could not have known that these deaths, too, had been dealt at the hands of their fathers.

If the exact identities of the lynch mob's members remain a mystery, a little more is known about the two men they hanged from the railroad bridge. The elder Hemmi, Peter, was born about 1836 in Switzerland. He appears in an 1884 San Luis Obispo newspaper article titled "An Old Building," which discusses the history of an adobe being demolished near Mission San Luis Obispo, connecting it with "a man named Hemmi" who operated it as a hotel as early as 1856. His name appears again in Internal Revenue Service tax rolls in 1863 and 1864 as either the owner or proprietor of an "eating house" in San Luis Obispo. The 1870 census places him in Arroyo Grande, married to Maria Hemmy (*sic*) and the father of infant P.J. In 1879, he filed a legal notice in the *San Luis Obispo Tribune* to take possession, under the Homestead Act, of a parcel in Lopez Canyon, with the endorsement of Ramon and Frank Branch and San Luis Obispo businessman J.P. Andrews.

At this point in Hemmi's life, something seems to go wrong. A year after the newspaper's legal notice, he is the butt of a gentle joke in a *Tribune* in a story about two local wagon accidents:

> *The other capsize was engineered by our friend from the Fabled Rhine, Peter Hemmi. Before starting down a rather steep decline in the road, he took the commendable precaution* [of locking both front wheels] *although his good wife reminded him that it was unnecessary, and he would doubtless be successful by inverting things generally if he only locked one. The sensible lady disposed herself and two little ones* [P.J. and Addie] *in the most advantageous position, and prepared to meet the catastrophe. Just as the horizontal parallels of the wagon assumed an angle of forty-five degrees to the perpendicular, she gave her largest baby a fling into the sand about ten feet distant, and then lit out herself with the other. Peter was not to be heard from. His wife was about to come to the conclusion that he had gone to Arizona—Tombstone District—when some men came up and found him covered up in the debris of his cart and its load of market sass.*

A man with a good sense of humor might have enjoyed this story told on himself. The story would have humiliated other men: the warning of imminent disaster by the "sensible" wife (what might that imply about her husband?), the overturned wagon that fulfilled her warning, the comic rescue of the heedless farmer by other men, who found him helpless, buried in the market vegetables that he'd worked so hard to cultivate. A man without a sense of humor might have seethed at being the butt of this joke.

There is no evidence that Peter Hemmi was the kind of man able to laugh at himself. After his death, there are multiple suggestions in newspaper accounts that he was covetous of and obsessive about a piece of farmland adjacent to his parcel in Lopez Canyon. According to the *San Luis Obispo Daily Republic*, he "annoyed a widow woman who formerly owned the land to such an extent that she was obliged to sell out" to a young couple originally from Redwood City, Eugene and Nancy Walker. Walker, said the *Republic*, "was a quiet, inoffensive man, well known in this city [Arroyo Grande] and well liked by all who knew him." He had worked as a printer in San Mateo County before he and his wife, the parents of a little girl, moved to Lopez Canyon. Peter Hemmi evidently picked up where he had left off with the widow; he was suspected of poisoning Walker's livestock and breaking down his fences to scare him off the land. Walker sought a restraining order to force Hemmi, who had begun to threaten his life, to leave him in peace;

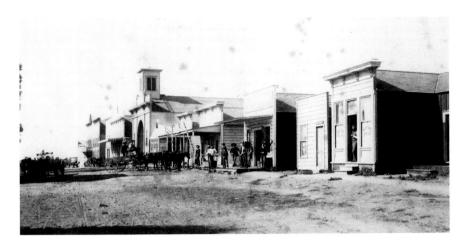

Branch Street, Arroyo Grande, in the 1880s. *South County Historical Society.*

the order was turned down for lack of evidence. On March 31, 1886, the neighbors' dispute finally turned deadly.

Eugene Walker was using a spade to turn over the soil in his vegetable garden when P.J.'s first rifle shot hit him in the back. He crumpled immediately, the spade across his chest. Nancy Walker heard the gunshot and came out of the house screaming. P.J. dropped her with a shot to the chest, the bullet piercing the young woman's lung. He must have been approaching the house, because he was close to Walker, who was attempting to get up, when he finished him with the third shot. The fourth hit Mrs. Walker again, shattering her arm, and the fifth was intended for her, as well, but the family dog distracted P.J. and he killed it instead. The young man stood for several minutes over the Walkers' motionless bodies before walking away.

Nancy Walker was still alive. Grievously wounded and, according to one newspaper account, pregnant with her second child, she crawled back to the farmhouse, collected her two-year-old toddler and began painfully crawling toward the Myrtle family's farmhouse, over a mile away. It was Mr. Myrtle who rode into town with the news. Sheriff A.C. McLeod and a deputy rode for the scene of the reported murders and found three neighbors who told them that Walker's body was in his kitchen, where it "was found lying on the floor, and the walls and the floor of the room were splattered with blood," probably that of Mrs. Walker, shed when she had returned for her child. They then rode to the Myrtle family's home to take Mrs. Walker's statement.

In the meantime, Peter Hemmi, P.J. and P.J.'s cousin, George Glesse, had been arrested and brought back to town by Arroyo Grande constable Thomas

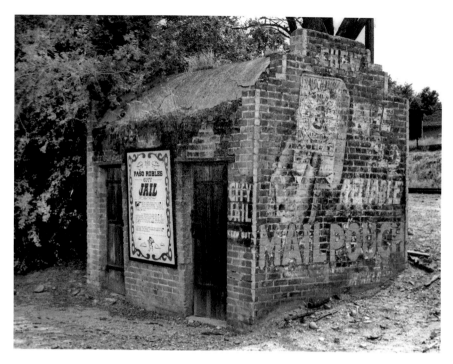

This small jail in Paso Robles would have been typical of county jails in the late nineteenth and early twentieth centuries. *From the* San Luis Obispo Tribune.

Whiteley, also the town's boot maker, and his deputy, Joseph Eubanks, and brought to the "calaboose," a small wooden jail near the creek on Bridge Street. The suspects were to be held here temporarily, until Sheriff McLeod could transport them to the jail in the basement of the county courthouse in San Luis Obispo. The three never made it. Whiteley described what happened next:

> *Myself and Eubanks guarded the jail during the forepart of the night. I left Eubanks in charge and I took a walk around town and all was quiet. Eubanks and I, being hungry, went to supper leaving Dan Rice [a* prominent local man who supervised the building of Arroyo Grande's roads] *in charge of the jail.*

Whiteley and Eubanks were interrupted in mid-meal by a mob who overpowered them and locked them inside a back room in Pat Manning's restaurant. The crowd then descended on the little jail, pushed Rice aside

This 1903 Sanborn Fire Insurance map shows the location of the Arroyo Grande jail, or "calaboose," in today's Olohan Alley. *Author's collection.*

and rushed the Hemmis and Glesse, probably along today's Olohan Alley, toward the northern edge of town. They brought their prisoners to the Pacific Coast Railway trestle over the creek. The elder Hemmi had enough time to persuade the mob to release Glesse, his nephew, whom he said had no part in the shootings. Glesse reportedly fled with the noose still around his neck and a length of rope trailing. The Hemmis were then shoved off the bridge into the chasm below. The two men strangled at the ends of their ropes.

While Eugene Walker's body lay on ice awaiting the arrival of his father from Redwood City, Maria Hemmi, the sensible woman who had warned her husband not to lock both wheels of their market wagon, drove what was probably the same wagon into town to fetch the bodies of her husband and son. The *Santa Cruz Sentinel* recorded a scene filled with Victorian melodrama:

> *When Mrs. Hemmi came to get the bodies of her husband and son, their faces were uncovered. She gazed on the face of her husband with a set and scornful countenance, but when she looked at Julius her face softened; she burst into tears, and exclaimed "Oh, my poor innocent boy! I know you done the deed. Your father made you do it. But as for him," pointing at the body of her husband, the look of scorn returning to her features, "I care nothing; he has been a brute all his life."*

Arroyo Grande thought both men brutes. They had, after all, tried to kill a young mother, just as the San Miguel Mission killers had killed Mrs. Reed. A local newspaper account said of the lynch mob "in this they did right," a sentiment echoed from the pulpit of the town's Methodist church, so there was no place in town for a Christian burial for the Hemmis. It was the town's matriarch, Doña Manuela Branch, who offered Maria Hemmi a grave site a few yards away from that of her husband's, the man who had founded Arroyo Grande. Father and son were buried there, in a common grave, in the hollow of a peaceful little oak-studded canyon about two miles east of town.

There was another factor besides the attack on Mrs. Walker that might have motivated the lynch mob. They were acutely aware of their own power. Only six weeks before the citizens of Arroyo Grande did away with the Hemmis, three hundred of them had descended on the little town's Chinese residents and ordered them to leave within twenty days, an incident that paralleled anti-Chinese violence in the West in late 1885 and early 1886. The February threat of mob violence against local Chinese appears to have been something like a dress rehearsal for the mob that lynched the Hemmis, and there may have an element of xenophobia in that event, as well.

The grand dame of South County historians was a local newspaper columnist during the 1920s and 1930s, Madge Ditmas. Fifty years after the lynching, Ditmas still shows the remnants of the resentment the town had for Peter Hemmi in the collection of her columns, *According to Madge.* She never names Hemmi, but refers to him as "The Frenchman." Peter Hemmi was an immigrant, and his English was probably heavily accented. This factor, too, may have doomed him and his son.

Nancy Walker was doomed, as well. She was reported dead, then near death, but Sheriff McLeod found her responsive, Constable Whiteley visited and reported her improved and when town doctor Ed Paulding treated her wounds—he was reputedly the best orthopedist in the county—he was amazed at her resilience. Dr. Paulding reported her weak but recovering her appetite, her wounds "healing nicely," and the healing was taking place without the need for opiates. Seven months later, she died at the home of relatives in Redwood City. Despite Paulding's optimistic report after the shootings, the *San Francisco Chronicle* reported that "the heroine of that awful experience lingered in great pain until her death." She was buried in Redwood City with her husband.

The identities of the men who had belonged to the lynch mob were never established, not even after a police detective spent a week in Arroyo Grande

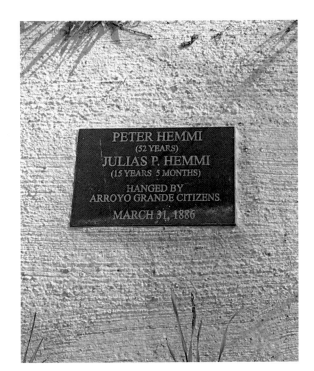

Right: The Hemmis' marker in the Branch family cemetery, Upper Arroyo Grande Valley. *Author photo.*

Below: Dr. Ed Paulding, shown here in his later years, treated apparently recovering gunshot victim Nancy Walker. *South County Historical Society.*

trying to pump information from its citizens. They remained steadfastly tight-lipped. In 2004, the town remembered the lynching with a somber ceremony. Arroyo Grandeans were now far more equivocal about this ugly incident from the past, while their 1886 counterparts had their action praised, even from church pulpits. Nevertheless, the members of the lynch mob may have had their own doubts about what they were doing, because they were sure to keep their faces covered by handkerchiefs when they broke into the jail and took the three men away from Dan Rice and the one other witness who had been there that night: Maria Hemmi.

Fred Jones, a young man about P.J.'s age, the grandson of Manuela Branch, was part of the mob, too, and he never forgot the look on Mrs. Hemmi's face when the masked men burst in. She knew exactly what was about to happen. And she would have easily recognized, without their masks, her neighbors. Some of their children went to the same school that P.J. and Addie attended. The Santa Manuela schoolhouse, saved in 1969 from the waters of Lopez Lake, nine miles away, now stands about two hundred yards from the place on the creek where the lynch mob's rope ended P.J.'s life.

6
ROBBERS AND COPS

It sounds today like an insult, but a *San Luis Obispo Tribune* reporter described Dick Fellows, in 1882, as a "*somewhat* famous outlaw." In fact, Fellows was a somewhat spectacular outlaw. In the previous year, he robbed five stagecoaches in San Luis Obispo County alone. Juan Francisco Dana remembered stage robberies, in the years before the railroads had been completed to close all the gaps between San Francisco and Los Angeles, as a regular occurrence, especially on the Cuesta Grade and along the San Marcos Pass, and Dick Fellows pulled off many of the robberies in Santa Barbara County, as well. If Fellows had better luck with horses, he might have gone down in western lore with his more famous counterpart in stagecoach robbery, Black Bart.

He resembled Bart in some ways: Fellows (his real name was George Lyttle) was intelligent and articulate. He had even studied law in his home state, Kentucky, intending, albeit briefly, to enter his distinguished father's law practice. Instead, a penchant for strong drink and low company led him to California, where, after the failure of a hog farm, he turned to stagecoach robbery to make ends meet. It was in the San Fernando Valley, early on in his fourteen-year outlaw career, where he discovered how fickle horses could be. One day, near dusk, Fellows stepped into the road in the Caheunga Pass, brandishing a pistol, and stopped the stage. When a passenger leaped out and fired his revolver at Fellows, the stage driver, in the moment of confusion that followed, whipped his six-horse team into a gallop and disappeared. He left the contrite passenger and the flustered outlaw in the dust. Fellows looked

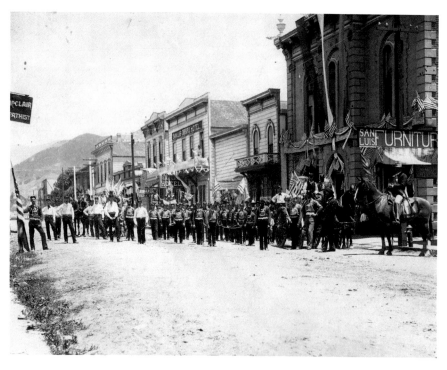

A firemen's parade on Higuera Street, in now-thriving San Luis Obispo, about 1890. Despite this scene of civic pride, law-breaking continued to interrupt the county's peace. *San Luis Obispo County Regional Photograph Collection, Special Collections and Archives, Cal Poly State University–San Luis Obispo.*

around for his mount. It had followed the stagecoach. He had to be content with robbing the passenger, who had meekly surrendered his weapon, and sending him, hands raised, on the road back to San Fernando. After another robbery in the Los Angeles area, Fellows was caught and began an eight-year sentence in San Quentin in 1870.

A model prisoner, Fellows was paroled in 1874 and soon resumed his career—and his bad luck with horses. While living in Caliente, east of Bakersfield, in late 1875, he decided to rob a Los Angeles–bound stagecoach reputedly carrying a large shipment of money in its Wells Fargo strongbox. As he lay in wait for his quarry, Fellows's horse bolted and threw him to the ground. He was momentarily unconscious, but it was the same moment when the stage and its strongbox, containing $240,000, dashed unharmed past the intended ambush spot. Fellows was a persistent man. He decided, once he'd regained consciousness, to rob the same stagecoach on its return trip to Caliente, and this time he was successful.

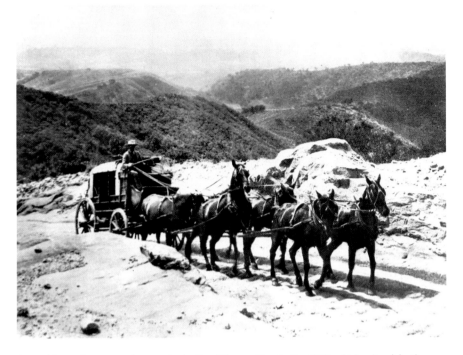

A northbound stagecoach ascends the San Marcos Pass in the 1880s. *University of Southern California Libraries/California State Historical Society.*

The driver threw down the heavy strongbox. Fellows was swinging it up into his horse's saddle—a new horse, hired from a livery—when the animal bolted and disappeared. The strongbox fell on Fellows's foot. Exasperated, he began to flee on foot, limping and dragging the strongbox with him. He then fell over a cliff in the dark, breaking his leg. He somehow stole a second horse, but unfortunately for Fellows, it was freshly shod, with one mule shoe and three horseshoes, and left a trail that was easy for authorities to follow. He was arrested near Bakersfield.

Because he was again a model prisoner, Fellows was released from his second San Quentin term in 1881, but he had gotten into the stagecoach-robbing habit now. This time, he shifted his territory to the area once terrorized by outlaws during the 1850s—El Camino Real between Monterey and Santa Barbara. He admitted later to investigators that he robbed the Santa Barbara stage seven miles south of San Luis Obispo in August 1881, robbed the San Luis Obispo stage near Soledad in December and robbed another Santa Barbara stage near Arroyo Grande later the same month. He was suspected in at least two more local robberies, but his luck finally

ran out once again. He was arrested by a Wells Fargo detective in late January, near San Jose, in Santa Clara County. Fellows was soon on his way to jail and, potentially, another prison term.

Fellows's luck with escaping was not much better than it was with horses. This proved to be the case in San Jose, where a Constable Burke decided there would be no harm in buying Dick Fellows one last drink before he booked him into the San Jose City Jail. When deputy and prisoner emerged from the saloon after their refreshment, Fellows disappeared around the corner. Both Constable Burke and the bartender gave chase. They lost the suspect. Fellows, however, was recaptured the next day and sent south—probably to the relief of Santa Clara County law enforcement officers—to Santa Barbara, this time to stand trial for

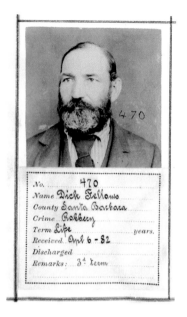

Outlaw Dick Fellows's booking photo, Folsom Prison. *California State Archives.*

a robbery near Los Alamos, a place made notorious by Salomon Pico and Jack Powers. Fellows had made a costly mistake. In this robbery, he'd taken the stage driver's easily identifiable gold pocket watch, which was found in the outlaw's pocket.

The watch was worth $100 but proved even more valuable in convicting Fellows for the third time, in March 1882. He was sentenced to the new penitentiary at Folsom. While Fellows was in jail in Santa Barbara awaiting transport north, Deputy Sheriff George Sherman opened the outlaw's cell to let him wash up for breakfast. The prisoner pounced on Sherman, wrestled him to the floor, took his revolver and sprinted for daylight. He found an unattended horse on Santa Barbara Street, mounted it and galloped away on an escape that lasted two full blocks. Fellows took a hard left turn off Santa Barbara Street, and his mount collided with another horse. The two animals got entangled, and in a frenzy of whinnying and bucking, Fellows was once again thrown. He was lying stunned in the middle of the street when he realized he'd been surrounded by a knot of enthusiastic men, armed with pistols, and one teenager, armed with a rifle. He surrendered. He was returned to jail, where he asked if he might not have his breakfast now. The deputies

An old stagecoach road from the Huasna Valley to Pozo. *South County Historical Society.*

brought him both breakfast and a fifteen-pound iron boot to slow him down should he try any more escapes.

Fellows didn't try. He proved himself a model prisoner in Folsom, just as he had in San Quentin. He taught classes in moral philosophy and Spanish, became the chaplain's assistant and, helped both by his behavior and by a barrage of letters to the governor from his family in Kentucky, was pardoned in March 1908. It was believed that Dick Fellows was on his way back to Kentucky to start his life over where it had begun, but his family never saw him again. He simply disappeared.

If the deadly 1850s were in the past, crime still plagued remote San Luis Obispo County. Fellows was just one of several "road agents" who robbed stagecoaches on El Camino Real. But even if it took three attempts to finally end Fellows's career, the regularity of his arrests revealed that the agents of civilization, including police forces, were beginning to make their presence felt. It was good police work, for example, that foiled a Cayucos bank robbery in 1892. When one-armed constable Peter Banks was escorting a horse thief, Peter Dunn, from Paso Robles to San Luis Obispo, they stopped to eat at Santa Margarita. Banks allowed his prisoner a generous portion of whiskey with his meal, and it paid off. Dunn, hoping for leniency, blurted out a plot, one that involved him, to rob the Cayucos bank after "butter day," when the

91

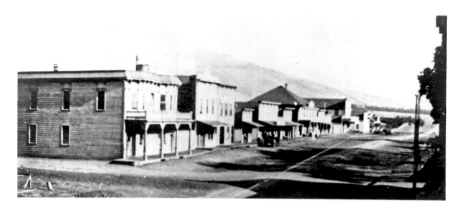

Old town Cayucos, the site for an attempted bank robbery in 1892. *Cayucos Historical Society.*

bank's vaults would be filled with deposits from the immigrant Swiss and Azorean dairymen so important to the economy of the little seaside town and to the county, as well.

Banks took both Dunn and his story to County Sheriff Ed O'Neal, and the sheriff laid a trap for Dunn's confederates, the would-be bank robbers. O'Neal, Banks, a deputy constable named Kue and Deputy Sheriff A.C. McLeod, who six years earlier, as sheriff, had investigated the shooting of Eugene and Nancy Walker, arrived in Cayucos; Banks and McLeod were inside the bank when the men, wearing cloth sacks with eyeholes cut out and escorted by a citizen posing as a bank officer, approached the vault. It was McLeod who startled them by bellowing "Hands up!" A volley of gunshots followed. McLeod went down, hit twice, but Banks wounded one of the robbers, who died the next day. McLeod survived with a souvenir, a bullet that remained in his back the rest of his life. Two of the robbers escaped as a prominent local citizen, James Cass, fired at them, missing the outlaws and hitting a telegraph pole. Ultimately, the two escaped criminals would be caught, one in San Diego and one in Sacramento, and sentenced to ten-year terms in prison. During the entire shootout, McLeod and Banks claimed, Sheriff O'Neal waited safely out of harm's way in a lot behind the bank.

If the memories of McLeod and Banks are accurate—and McLeod, potentially a political rival of the sheriff's, might have had motive to embellish his story—there was a better template than O'Neal for county lawmen. It was the enigmatic but tough man who was the sheriff at the height of the county's most violent years: Francisco Castro, who served from 1856 until 1863. Castro remains an ambiguous figure because his authority was

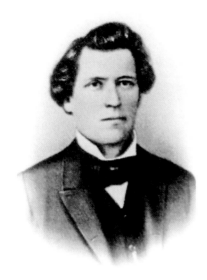

Sheriff Francisco Castro.
Tim Storton Collection.

apparently superseded by the vigilance committee for several weeks in 1858. Yet there were five different sheriffs between statehood in 1850 and the beginning of Castro's tenure in 1856—San Luis Obispo's first sheriff, Henry Dalley, resigned after only a year because the job was simply too dangerous—so the length of Castro's term alone suggests a tough man. Castro's name appears among a list of prominent citizens who endorsed Walter Murray's account of the vigilance committee, but there is a note of peevishness in a note the sheriff wrote to the board of supervisors, demanding the replacement of the jail door broken down by the vigilantes and, for good measure, improved handcuffs and restraints. In another note, he notes that without locks, he, as sheriff, "will not be responsible for any prisoner who may desire to get up and git." Castro, in fact, would get a brand-new jail at the corner of Palm and Santa Rosa Streets, near the present courthouse complex, one that historian Dan Krieger describes as "the best built and only up to date building in San Luis Obispo at the time of the Civil War."

Castro seemed no less afraid of confronting criminals than he was of confronting local politicians. He had, after all, led the posse that waged a gunfight against Pio Linares at the edge of San Luis Obispo in 1858. On August 23, 1859, Castro again proved his mettle by carrying out the only legal execution in county history, the hanging of convicted murderer Luis Carrizoza. The execution took place, according to Castro's report, at 9:30 a.m. behind the jail, still located at the end of the mission colonnade. The execution was private, behind the walled-in enclosure that includes what is today the gardens and parking lot behind Mission San Luis Obispo, and at Carrizoza's request, Castro "invited the Rev. Juan Compala, a minister of the gospel, and the said minister was accordingly present and attended said Carrizoza at said execution."

As was often the case with Wild West lawmen, Castro's life ended as violently as Carrizoza's had. Castro lived in an adobe along today's Ontario Road, and in August 1878, he opened the gate in his front yard and walked

Old Mission San Luis Obispo. The first county jail was in the rooms at the end of the colonnade. *Library of Congress.*

into the road to confront a horseman, a man named Thomas Jones. The coroner's inquest that survives gives no indication as to the nature of the dispute between Castro and Jones, but it obviously came to a head at about 5:30 p.m. on Tuesday, August 20. Witness Trinidad Howard heard the two men "disputing in English and using bad language." Another witness, G. Castillo, "was cutting beans near the RR track" and heard the same argument. He looked up to see a pistol in Castro's hand. The former sheriff cocked the hammer and pulled the trigger, but the pistol misfired. Jones then discharged his pistol, and Castro did the same on his second try. Both men missed. Jones then attempted to dismount from his horse, got tangled in the stirrup, fell and fired at Castro from the ground. This time, one of the bullets hit Castro, who gave up trying to shoot the man on the ground and instead began beating him with his revolver. Castro pistol-whipped Jones to death in the road, but the former sheriff lived for only twelve more hours. It was, of course, senseless, as was the Hemmi lynching eight years later. It must have seemed that frontier days were dying as hard as Sheriff Castro had.

The decade following Castro's death, however, seemed to see an acceleration in the pace of taming what had once been the most violent county in America. The arrival of a rail connection between Port Harford and San Luis Obispo began to break down the region's traditional isolation; evidence for this comes from an archaeological dig at the site of the 1876 Immaculate Heart Academy on Palm Street in San Luis Obispo, the site of today's Mission Prep. Excavation of the academy's privy in 2002 produced artifacts related to student life, confirming that about half the students in the academy's first years were boarders; they'd left behind prescription medicine bottles from as far away as San Bernardino and San Francisco.

The founding of the Immaculate Heart Academy itself was reflective of the continued evolution of a county population that was becoming more family oriented. Myron Angel's 1883 *History of San Luis Obispo County* includes a list of over fifty public schools, some no bigger than the Santa Manuela School in Lopez Canyon, with a countywide total of nearly 2,800 students. When teacher Clara Paulding came to Arroyo Grande in the 1880s, she found the place, as her daughter and biographer Ruth put it, "a rather wooly town," with seven saloons within a short walk of Branch

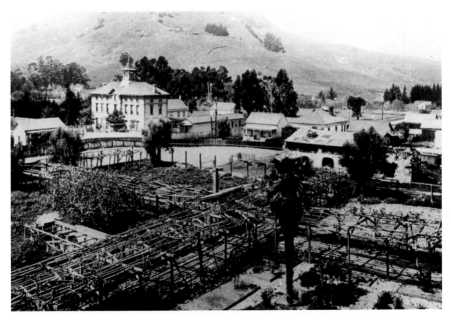

Grape arbors in the Mission San Luis Obispo gardens, the site for the only legal hanging in county history. Just beyond is the two-story Immaculate Heart Academy *San Luis Obispo County History Center.*

and Bridge Streets, but Clara would do as much as anyone to "civilize" the little town. After she homesteaded in Cholame, Clara would marry and settle in Arroyo Grande to teach in the town grammar school; at Branch School in the Upper Arroyo Grande Valley, where she was the only teacher for sixty students in eleven different grades; and at the remote Huasna School, where she would board with a family for the week, come home to Arroyo Grande on weekends and prepare the following week's meals for her husband, town doctor Ed Paulding. She also was a co-founder, in 1896, of the high school. She ended a teaching career of fifty years by teaching a final year, in her early seventies, in Oceano, so she could afford a new porcelain kitchen sink and a set of dentures.

During Clara's lifetime, a substantial middle class emerged, thanks in part to the extension of the Pacific Coast Railway into Arroyo Grande in 1881. (It is a cruel irony that these townspeople would use the PCRR bridge for the 1886 Hemmi lynching.) The fertile soil of the Arroyo Grande Valley, which produced a variety of fruits and vegetables, was legendary. Real estate agents boasted of gargantuan onions or tomatoes, and it was the immensity of the valley's pumpkins that had first persuaded Clara Paulding's physician husband, Ed, to settle in Arroyo Grande; any town able to grow pumpkins that size, he reasoned, ought to be able to support a doctor in fine style. Now, for the first time, the little narrow-gauge railroad provided efficient access to markets. As a result, most of the new settlers were farmers and family men—over fifty were Civil War veterans—and they sought the kind of stability that an earlier family man, Judge Walter Murray, had wanted for the county during the days of the Powers-Linares gang. Meanwhile, the population of the county nearly quadrupled between 1870 and 1910, from 4,772 to 19,383. If families and schools were products of that growth, so were more modern institutions for enforcing the law.

In 1879, a new state constitution brought a modernized Superior Court, which took sole jurisdiction over felonies, to the county. A single judge—the first one, Louis McMurtry, took office on January 5, 1880—presided over those cases, and a study of the San Luis Obispo Superior Court between 1880 and 1910 revealed that jurisprudence was marked by its rationality and restraint. Only two death sentences, for example, were handed down by the San Luis Obispo Superior Court in that thirty-year period. Historian Lyle A. Dale studied examples of the 744 cases brought before the court, and assault, grand larceny and burglary cases accounted for 65 percent of the criminal indictments. He reached the conclusion that "crime in San Luis Obispo was not particularly violent and aggravated, nor the result

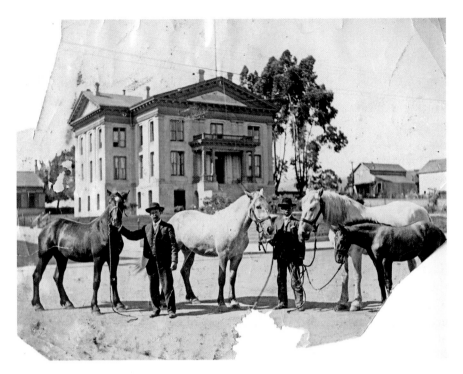

Farmers proudly pose with their draft horses in front of the San Luis Obispo County Courthouse. The sheriff's office and county jail were in the basement. *San Luis Obispo County Regional Photograph Collection, Special Collections and Archives, Cal Poly State University–San Luis Obispo.*

of hardened criminal activity." Many assault cases involved drunkenness; others involved extenuating circumstances that led to reduced charges. Fully half of the indictments for murder resulted in either a "not guilty" verdict or conviction on a lesser charge, such as manslaughter. Dale's portrayal of the Superior Court provides a stunning contrast to the days when a lynch mob broke down the door of the little mission jail.

Two examples of violent crimes that resulted in "not guilty" verdicts involved law enforcement officers, and consistent with Dale's study, they involved alcohol as well. In July 1880, San Luis Obispo police officer Frank Grady shot John Kith to death in the People's Exchange Saloon, on the corner of Monterey and Morro Streets. A drunken Kith, after nearly falling out of his chair, had stood up and angrily announced there wasn't a man in the saloon who could knock him down. When Grady lowered the newspaper he was reading and smiled, an enraged Kith advanced on him. Grady fired two shots from his revolver. The first hit Kith and the second missed, but

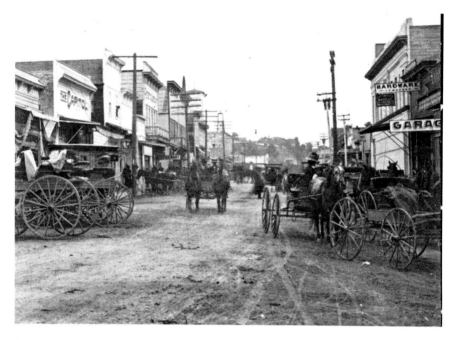

Branch Street, Arroyo Grande and the Capitol Saloon, *at left*, at about the time that George Roberts shot Constable Lewellyn. *South County Historical Society.*

as the drunken man lurched for the door, Grady fired a third shot, which severed Kith's spinal cord. He died on the street fifteen minutes later. Despite the fact that Kith was unarmed, and despite the deliberate manner in which Grady seemed to kill him, a jury returned a verdict of "not guilty." The two men had a history of enmity, and although a disapproving newspaper objected to the acquittal, it noted that many of Grady's friends had testified under oath that Kith had threatened to kill the lawman. The reporter found their testimony less than convincing.

In the second case, a police officer, Constable Henry Lewellyn, was the victim, gunned down in March 1904. Small-town policing in the first third of the century was dangerous. In North County, two Paso Robles officers were shot. In 1912, a transient fired several shots that hit Paso Robles night watchman John Rude. Rude survived, eventually becoming a police captain. Another Paso Robles watchman was murdered by two burglars in 1919; both men went to prison, where one was eventually killed by another inmate. Arroyo Grande's Lewellyn was shot down in the doorway of the Capitol Saloon on Branch Street. The officer had gone to the saloon to disarm a local man, George Roberts, who had been firing his pistol into the air along

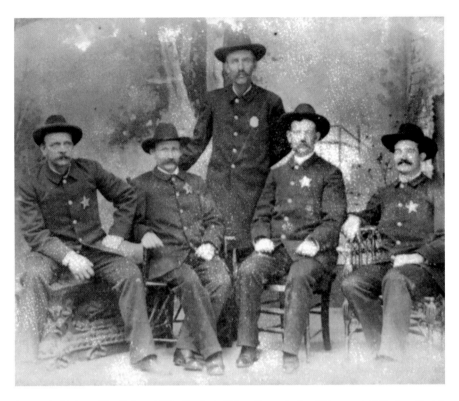

San Luis Obispo City Police, 1898. *San Luis Obispo County Regional Photograph Collection, Special Collections and Archives, Cal Poly State University–San Luis Obispo.*

Branch Street. Roberts shot Lewellyn at close range in the chest, and the constable died the next day at the nearby Ryan Hotel. Meanwhile, a posse tracked Roberts, who fled on foot, to Price Canyon as darkness fell. They fired several shots at him, but he escaped. His escape was short-lived. Sheriff Yancey McFadden and two deputies found him the next day in Oceano and took him into custody.

Killing a peace officer fifty years earlier doubtless would have resulted in a hard end for a man like Roberts. As it turned out, he would die a natural death, probably after a heart attack, at his Santa Ynez ranch house in 1934; a San Luis Obispo jury had returned a "not guilty" verdict in June 1904 on grounds like those in Officer Grady's acquittal: there was bad blood between the constable and Roberts and the latter had reason to fear for his life when Lewellyn appeared in the doorway of the Capitol Saloon. Five years later, a jury would not be so forgiving in the murder of a woman who was married to one of San Luis Obispo's most prominent citizens.

THE MURDER OF SILVER DOVE

The only known photograph of Gon Ying Louis, in various sizes, some black-and-white, some sepia-tinted, appears over and over in the Louis family papers in the University Archives at Cal Poly San Luis Obispo. It is not hard to understand why: she is exquisite, and her children, eight of them, must have been proud of her, proud of this photograph, and above all, they must have missed her. She died, at forty, in her sleep on September 30, 1909, with Howard, her baby, sleeping next to her, but hers was not a peaceful death. A single shot to the head from a .38-caliber revolver ended the life of Gon Ying, or "Silver Dove," a name appropriate to such a beautiful woman.

Gon Ying's murder is an anomaly in the history of the Chinese community in San Luis Obispo, one dominated by her husband, merchant and businessman Ah Louis. Their children, like those of nearly all Chinese immigrants, were hardworking and, more, they were talented. They included businessmen, a jeweler, a concert pianist, an army officer and a vaudeville singer, and the youngest, Howard, would grow up to be a philanthropist and one of the most beloved figures in county history, a man who, in old age—he died in 2008, just past his 100th birthday—loved to visit classrooms to share stories with children about growing up along Palm Street, in San Luis Obispo's Chinatown. Howard Louis was a handsome man, a quality he may have owed to Silver Dove, but it was his community-mindedness and generosity of spirit that may be the legacy he inherited from his father.

Ah Louis was not his father's real name. Ah Louis began his life in 1840 in Guangdong, in southeast China, as Wong On, during a turbulent time

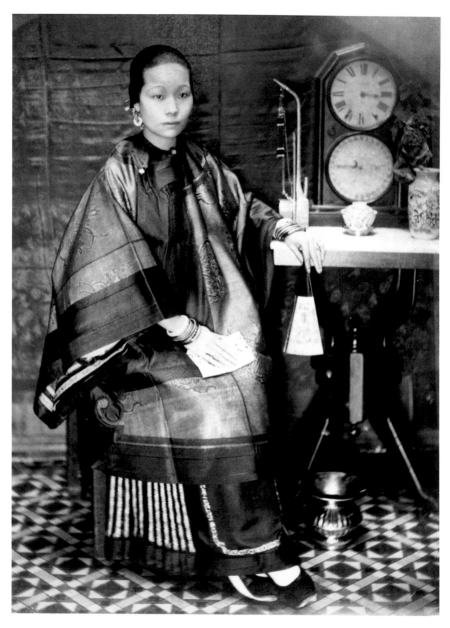

Gon Ying. *San Luis Obispo County History Center.*

in the nation's history. China was experiencing the humiliation of its defeat in the First Opium War, a conflict won by British gunboats in defense of that nation's immense profit-taking in drug sales, which balanced the books against Britain's importation of and addiction to Chinese luxury items, including silk and tea. The ineptitude of the Qing dynasty in dealing with Western imperialism would also be a factor in provoking the Taiping Rebellion, a revolutionary convulsion that may have claimed as many as thirty million lives between 1850 and 1864. Ah Louis's own feelings toward the Qings were made clear in December 1911, when he flew a rebel flag over his Palm Street store, honoring the fragile republic just being born under the leadership of Sun Yat-sen.

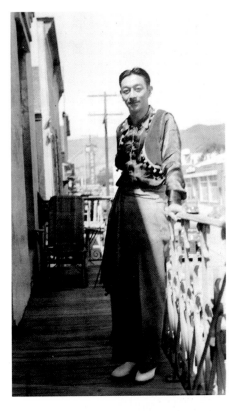

Howard Louis as a young man, posing outside the family's apartments, is in costume for La Fiesta, San Luis Obispo's celebration of its Spanish/Mexican heritage. *San Luis Obispo County Regional Photograph Collection, Special Collections and Archives, Cal Poly State University–San Luis Obispo.*

Wong On's personal liberation from the chaotic China of his youth had begun with a two-month voyage in 1860 to the West Coast, where, like many young men from Guangdong, he hoped for luck in the gold fields of Northern California and Oregon. In this, like his fellow immigrants, he would be disappointed, but he found steady work as a cook and relief from the asthma that had plagued him as a youth when he came to San Luis Obispo's French Hotel. Several months later, he began working on a ranch near Laguna Lake in San Luis Obispo for John Harford, who took an immediate liking to the young man but evidently had trouble pronouncing his name. It was Harford who began referring to Wong On as Ah Louis. Harford also provided the immigrant with a new identity in other ways. He recognized in him a potential businessman and made the arrangement that would launch Ah Louis's business career. It was Ah Louis

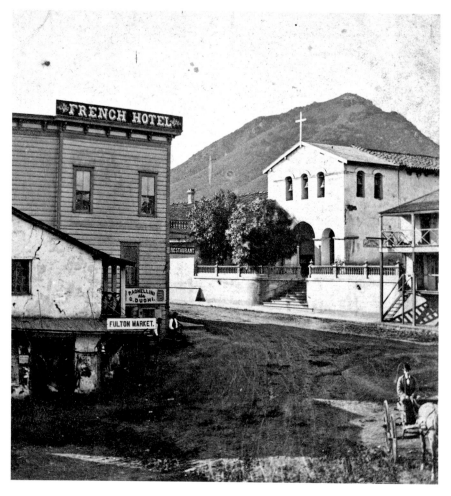

Ah Louis worked as a cook at the French Hotel, seen across from Mission San Luis Obispo in this nineteenth-century image. *San Luis Obispo County History Center.*

who contracted 160 Chinese laborers from San Francisco, in 1873, to begin building the railway track that would connect Port Harford, today's Port San Luis, with San Luis Obispo.

For the next two decades, Ah Louis would work to build a small but diverse business empire. He would continue to contract immigrant labor to lay track and to build local roads. He would begin to grow flowers and vegetables on land south of San Luis Obispo and would drain marshland around Laguna Lake to put it into cultivation as well. He would found a brickyard that provided the building material for several structures in the bustling little

Chinatown, early 1900s, with the Ah Louis Store at left, flying a large Chinese flag. The steeple atop the Immaculate Heart Academy can be seen just beyond the store. *San Luis Obispo County History Center.*

town of San Luis Obispo. He also started a store for his laborers in a small frame building that would be replaced in 1885 by the structure, the Ah Louis Store, built with Ah Louis bricks, that still stands today on the corner of Chorro and Palm Streets. The local press praised both the looks of the new building and the success of its owner. What Ah Louis had accomplished by 1885 was remarkable.

What made Ah Louis's success even more remarkable was its timing. It came as the nation struggled to emerge from a prolonged depression that had begun in 1873; unemployment would peak at about 8 percent by 1878. Congress passed the 1882 Chinese Exclusion Act in response to agitation on the part of white workers, who, in California, rallied behind demagogue Denis Kearney and his Workingmen's Party. Kearney and his followers claimed that immigrant competition absorbed jobs and depressed wages.

Other white workers went far beyond political action in the Far West. Expressions of anti-Chinese bigotry had been episodic but violent in California's past—many of Joaquin Murieta's victims were Chinese

miners—and the violence seemed to reach a peak at about the time the Ah Louis store was completed. Anti-Chinese rioting erupted in 1885 in Tacoma and Seattle. Federal troops had to be called into Rock Springs, Wyoming, to put down riots that had killed twenty-eight Chinese miners. In Wyoming, a silver boom was playing out, but the lower wages that were the result were blamed, as they had been by the Kearneyites in California, on competition between white and Chinese miners. Two years later, thirty-one Chinese miners were murdered and their bodies mutilated in Hell's Canyon, Oregon.

It was in November 1885 that the first formal threat to San Luis Obispo's Chinese came with the formation of an anti-Chinese club, which adopted Denis Kearney's motto: "The Chinese must go!" A mob in Arroyo Grande ordered the Chinese out of there soon after the end of the rioting in Washington. Five days after the Hemmi lynchings in April 1886, Chinese men working on the Pacific Coast Railway near Nipomo were surrounded by another crowd, said to be from Arroyo Grande, which ordered them to leave, threatening to hang any man who returned. In San Luis Obispo, hostility had centered on Chinese washhouses, said to have a monopoly on the city's laundry business and representative, so long as they were successful, of a permanent Chinese presence in the city. A competitive white laundry opened on Osos Street in 1876. In 1880, a city ordinance attempted to limit the Chinese washhouses' hours, and in 1883, Chinese laundry workers went on strike when the city council imposed a sharp fee increase on their business licenses. A second competitor, named, with a stunning lack of subtlety, the Caucasian Steam Laundry, opened in 1886. In 1894, at attempt was made to blow up the laundry owned by Sam Yee. The cumulative effect of what included acts of terror was an exodus of Chinese from the county.

Ah Louis remained, and along with the Chong and the Gin families, the Louis family would remain a constant and vital cultural presence into the next century. What may have made that possible was the apparent ease with which Ah Louis lived a bicultural life. He returned to visit China twice, funded the founding of a Chinese school in the joss house (temple) at 818 Palm Street and supported new Chinese businesses, like the New China Café, which opened four doors down the street from the Ah Louis store in 1913. At the same time, he aimed much of the merchandise in his store, imports from China and Japan, at white consumers, especially at Christmas; celebrated the Fourth of July; and invited non-Chinese family friends to celebrate the Lunar New Year with his family.

It was his children who would make the intercultural connections even stronger: Helen Louis was a gifted pianist who performed a solo at a 1912

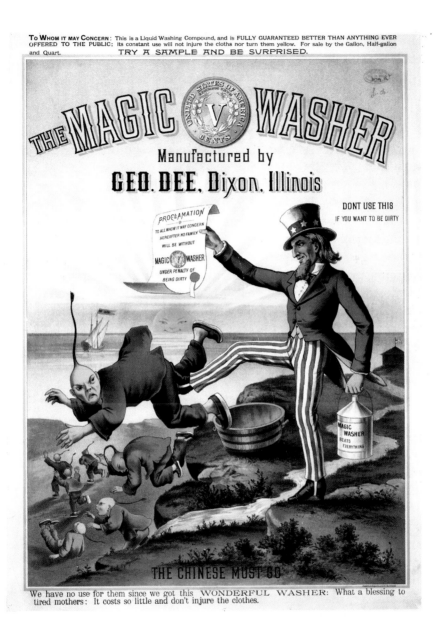

This advertisement for a cleaning agent includes an anti-Chinese message typical of the 1880s. *Library of Congress.*

temperance revival; the January 1913 wedding of Young Louis to Stella Chandler, "dark eyed and endowed with the beauty of the Orient," was described in breathless detail in the local newspaper; vocalist and steel guitarist George Louis performed in concert at the Elmo Theater in 1923, where his brother was the film projectionist; later in the 1920s, Howard Louis was a small but speedy back for the San Luis Obispo Tigers football team that elected him their captain; Fred Louis demonstrated his prowess as a wrestler at the University of Chicago in 1931–32; and granddaughter Elsie Louis won the California state spelling bee in 1928. A son from a previous marriage, Willie Luis, as his name was spelled in official records, was invited by his father to take up residence in 1905 in rooms behind the store; he began to help run the family business.

In 1889 San Francisco, Ah Louis had met his second wife, the woman who would raise, feed, teach and discipline his eight children. Gon Ying was twenty years old and Ah Louis forty-eight when they married and returned to San Luis Obispo to live in the apartments above the store. Gon Ying Louis appears to have lived in a kind of Chinese version of *purdah*. She was known to have left the building only twice in the next twenty years, a situation, author Iris Chang writes, not uncommon to Chinese immigrant

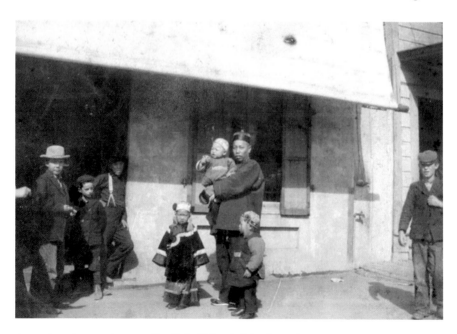

A meeting of two cultures on San Luis Obispo's Palm Street in the early 1900s. *Sinsheimer Family Collection, Special Collections and Archives, Cal Poly State University–San Luis Obispo.*

women on the frontier. Their husbands were motivated by a combination of possessiveness and fear for their wives. Attacks on women in what had been, since Gold Rush days, a male-dominated society, and one prone to violence, were not uncommon. Since the overwhelming number of Chinese immigrants to California were male, Ah Louis must have seen this, too, as a threat to his young wife. Gon Ying would at least have had the comfort of visits from other Chinese American wives. She may have even helped to host the celebrations and dinners her husband put on to cement his business and personal relationships with the larger community. Judging her by her children, she must have been a wonderful mother. In 1909, her husband would learn a sad lesson from his second marriage: he could confine his wife, Silver Dove, but he could not protect her.

The man who was responsible for protecting the citizens of San Luis Obispo was an Irish American who could have come from central casting. Sheriff Yancey McFadden was born in Paso Robles and grew into manhood with the same kind of barrel-shaped body and gregarious nature that marked future baseball star Babe Ruth. A later sheriff, Larry Mansfield, once posed grinning while showing off McFadden's gun belt, whose holster once held a .32-caliber revolver, and the belt could have easily wrapped around two Larry Mansfields. McFadden could have been cast as a Tammany Hall precinct captain—even better, as an alderman—or, of course, as a sheriff. His appearance and the comfort of his place in San Luis Obispo County in 1909 is mindful of the Monterey County sheriff portrayed by Burl Ives in Elia Kazan's film *East of Eden*. His name seems to have been part of his appeal. The building atop Calle Joaquin, just south of San Luis Obispo, now the headquarters for KSBY television, was once a crowded bar and disco called Yancey McFadden's.

McFadden policed an area three times larger than Rhode Island with an undersheriff and a minimal staff. His headquarters, and the county jail, took up the basement of the old county courthouse (its single-handed demolition by young Alex Madonna in 1939 would mark the beginning of the Madonna Construction Company), but he was often on the move. A glance at newspaper articles about McFadden in 1908–9 reveals him traveling to Los Angeles to depose the former mother superior of the Immaculate Heart Academy, who had witnessed a crime; heading north, on

several occasions, to deliver prisoners to San Quentin; arresting a man in Santa Barbara wanted for crimes here; and making other official calls as far north as Shandon and as far south as Nipomo.

McFadden had reason to carry his revolver, a small weapon for a man so large; he'd participated in the manhunt that ended with arrest of armed suspect George Roberts, the killer of Arroyo Grande Constable Henry Lewellyn. In 1906, he'd fired shots at fleeing boxcar thieves who had looted liquor from the Southern Pacific yard in San Luis Obispo. But most of his policing was less dire. He arrested a gambler in "El Pizmo," or Pismo Beach, who was fined $100; he jailed a weeping drunk on Monterey Street in San Luis after

Sheriff Yancey McFadden.
Tim Storton Collection.

the sad man had fallen off a garbage can; found a Shandon horse thief in Lompoc and a Santa Barbara burglar in Guadalupe; and investigated, in a story covered somewhat ironically by the *Daily Telegram* ("CAYUCOS STIRRED," a large headline proclaimed), the disappearance of ten dozen bottles of beer from Mr. Bianchi's saloon. McFadden was familiar with Chinatown as well. In August 1909, accompanied by three deputies, he raided an opium den on Palm Street and arrested four Chinese men.

What was probably the most important case of McFadden's life came to him from Chinatown at the end of September 1909. McFadden was visiting San Miguel when he was summoned to the telephone for a call from his undersheriff, James Walsh. Ah Louis's wife, Gon Ying, had been murdered in the family's apartments over the store. McFadden hung up the phone, rushed to the street and grabbed the reins of a buggy he believed to be that of a friend who was with him in San Miguel that day. It was the wrong buggy. The sheriff had to suffer the humiliation of being chased down by a citizen who was shrieking "Stop the thief!" McFadden obliged, stopping the horse, and red-faced, he apologized for his mistake. He later continued south to investigate the homicide that would dominate newspaper headlines for the next two months. McFadden was a small-town cop, but the police work he did in the first week of October 1909 was worthy of any skilled big-city detective.

A coroner's jury, like the one that had assembled for the Hemmi lynching in Arroyo Grande, gathered close in the apartments above the Ah Louis Store. Gon Ying was dead in her bed, her face turned toward the wall, with a bullet hole midway between her cheekbone and temple. The shot had been fired close enough to leave powder burns. She had died while her husband was in the South County; he left by train at 6:00 a.m. that day, a Thursday, to visit Lewis Routzahn's sweet pea farm in Arroyo Grande. After seeing her husband off at the door, she had apparently gone back to bed. She was asleep, with toddler Howard next to her, when she was shot. A daughter woke up and smelled the burnt gunpowder but went back to sleep, thinking she was dreaming of New Year's fireworks. Another daughter in a nearby bedroom heard the gunshot and then footsteps descending the staircase. She lay in her bed, frozen with terror, until the cries from the children in her mother's room roused her. After finding her mother dead, she awakened her half-brother, Willie, who slept downstairs in a backyard shed, and then the undersheriff was summoned. It was the children and a grief-stricken Ah Louis, upon returning from the Routzahn farm, who established the motive: two boxes were missing, containing a small amount of cash but also some $5,000 in jewelry. It was a robbery. But why had Gon Ying been shot? Had she discovered the thief in the act? If so, why had she been shot at point-blank range, apparently while asleep and facing the wall?

These were loose threads that bothered Sheriff McFadden as he began investigating the murder. It only took him three days of questioning to decide to take the Southern Pacific train north to San Francisco. Gon Ying's body, as was customary among Chinese immigrants, was to be returned to China for burial. Her stepson, Willie Luis, had accompanied her casket to arrange for its shipment home. McFadden shadowed Willie for two days, returned to San Luis Obispo for a warrant and then arrested Ah Louis's forty-one-year-old son in San Francisco on October 5. What evidence he had, at this point, was circumstantial, but the sheriff and other investigators, including both peace officers and eager, self-deputized newspapermen, would find much more tangible evidence on October 6. A dig in the yard behind the store, in a garden kept by Luis, revealed the missing jewelry and a cash box, and $336.50 was found in Willie's bureau. The sheriff then ordered the cesspool behind the store pumped out, and two days later, searchers recovered a .38-caliber Colt revolver.

Documentary photographer Arnold Genthe took hundreds of photos of San Francisco's Chinatown between 1896 and 1911, including this street scene. *Library of Congress.*

When he was confronted with what McFadden had found, Luis confessed everything to a substantial audience: McFadden, District Attorney Albert Nelson, stenographers, three San Luis Obispo Chinese residents, reporters and an interpreter recommended by Ah Louis. The killing, as it turned out, had been motivated by both greed and four years of increasing animosity, since Willie Luis's arrival from China in 1905, between himself and his stepmother. It was an ugly domestic drama played out in a small place above the Ah Louis store—nearly as small and as crowded as was Luis's dark basement cell, filled with eager listeners, in the county courthouse.

Two powerful emotions must have filled the family apartments on above the store: one was the love, and the protectiveness, Gon Ying felt for her eight children. The other was the poisonous hatred that developed between her and Willie Luis, whom she saw as an interloper. In his confession, Luis depicted a haughty woman who constantly reminded him that the family's property belonged to Ah Louis and would be inherited by her children. Willie, in turn, had done little to ingratiate himself with his stepmother. He

offered another shed in his father's backyard to a live-in prostitute, Nettie Perry, a situation intolerable for a mother who was intent on raising children who would be good citizens. Willie probably overplayed his hand when Ah Louis mused about returning to visit China. He must have aroused Gon Ying's suspicions when he insisted that she go, too, and leave him in charge of his father's store.

In his jail interview, Luis admitted that he had contemplated killing his stepmother for "a very long time." This must have been, for San Luis Obispo residents, a reminder of another prominent family's ugly quarrel, in 1897, that reached a climax when John Dallidet fired two blasts from a shotgun to kill his brother, Pierre, in the yard of the home built by their pioneer father. John was eventually acquitted; his brother's temper was mercurial, he was abusive toward the elder Mr. Dallidet and the jury agreed with witness testimony that John had reason to fear for his life when he killed Pierre.

By contrast, Willie's murder of his stepmother seemed far more coldblooded. As authorities continued to question him, he identified the Colt revolver and the stolen items and described how he crept into Gon

San Luis Obispo's Dallidet Adobe was the site for another family quarrel that led to homicide. *Photo by Konrad Summer/Wikimedia.*

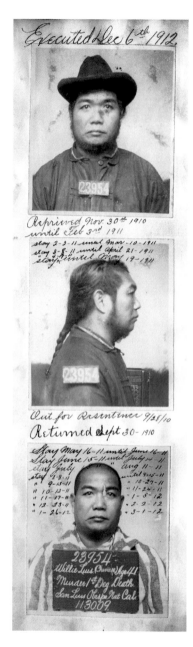

Willie Luis's booking photos, San Quentin, where he would be executed in 1912. *California State Archive.*

Ying's room, shot her and took the missing boxes. And then, incredibly, he pleaded not guilty at his arraignment on October 22, 1909. He would testify that he made the confession only in the hopes of getting a sentence short of the death penalty. In a later appeal filed on Luis's behalf, his lawyers claimed that he was improperly induced to confess, but the appeal was denied by the California Supreme Court. The only potential influence on Luis came from a jailhouse visitor named Wong Bick Yue, who told Willie about a half-hour before the investigators' interview, "If you did it, the best thing is to confess, I think."

The November 1909 trial lasted four days. Willie Luis, who sat throughout the proceedings without understanding most of what was being said, was quickly found guilty. The penalty determination was far more difficult. In 1909, there was substantial opposition to the death penalty, implied in District Attorney Nelson's summation, which reminds the jury that it is not *they* who would put Willie to death, but the laws of California that would *require* the death penalty. His argument was not immediately persuasive. After nearly four hours of deliberation and seven ballots, an exhausted jury decided, at 5:00 p.m. on the day before Thanksgiving, that Luis would be executed.

After losing his appeals to higher courts—while he was among those on death row, bills to end the death penalty were defeated in the state legislature, as well—Luis died on December 6, 1912. Witnesses described him as smiling as he climbed the platform at San Quentin

Ah Louis in the 1930s. *San Luis Obispo County Regional Photograph Collection, Special Collections and Archives, Cal Poly State University–San Luis Obispo.*

and continuing to smile as the noose was tightened. At this point, a death-penalty opponent interrupted the execution: "Jesus would not do this thing!" he shouted before being taken away. He did no good. At 10:00 a.m., the trap beneath the condemned man collapsed, and Luis fell, breaking his neck. Fourteen minutes later, his body was cut down. A witness claimed that, back in San Luis Obispo, Ah Louis trembled when word of the execution reached him. No one knows who, if anyone, claimed Willie Luis's body.

8

DESPERADOS

I t was the Gold Rush that first brought the James brothers to California. Robert James was a passionate and charismatic preacher in a little wood-frame church in Clay County, Missouri, and, as a slave owner, he followed the Southern Baptist Convention in the schism, over slavery, that had split the American church in 1845. Five years later, he felt the call to bring the Lord to the gold fields, apparently seized by the same missionary impulse that had brought the Methodist missionaries on the hapless *Arkansas* to San Francisco, where the ship ran aground on Alcatraz. Meanwhile, Robert's brother, Drury, had come to the gold fields in 1849. It would be difficult to find two brothers more unlike each other. Drury Woodson James was pragmatic and ambitious. When he arrived in Placerville from Kentucky, he used the gold he did find to get out of the gold-mining business. Like others, he soon recognized that the real money was to be made in supplying the needs of the thousands of miners converging on California. He began investing in cattle and, by 1860, was able to buy, with a partner, ten thousand acres in the La Panza district of northern San Luis Obispo County, near Paso Robles.

Meanwhile, Robert James's California sojourn ended tragically. He died of cholera in Rough and Ready, California, in 1850. Unlike his businesslike brother, he also died deeply in debt. A fellow Missourian who had nursed Robert in his last days sold the preacher's mule, valise and boots and took the last ten dollars from his wallet to pay for the expenses of his care. Robert James was then buried in a grave that has been lost to history, but the two

Left: Rancher and businessman Drury James. *San Luis Obispo County History Center.*

Right: Jesse James, a seventeen-year-old "bushwhacker," about four years before he came to San Luis Obispo County. *Library of Congress.*

sons he left behind in Missouri, seven-year-old Frank and three-year-old Jesse, would not be forgotten.

Eighteen years later, Frank and Jesse James, not yet famous, were living, for a time, on their Uncle Drury's ranch. Their careers as bank and train robbers would get their real beginning the following year, in 1869, in one of the first daylight bank robberies in American history. Jesse thought he recognized an old Civil War adversary in the Gallatin, Missouri bank cashier, John Sheets, who was changing a $100 bill for Frank. Jesse drew his revolver and shot Sheets in the chest; as his victim began to slump, Jesse cocked his revolver and fired a second shot into the man's forehead. He then grabbed a file full of what turned out to be worthless bank documents, not cash, and the brothers made their escape. It was by no means twenty-two-year-old Jesse's first killing, but it was one of his most tragic. In a case of mistaken identity, he had killed the wrong man. In the process, he also succeeded in having a price put on his head for the first time. That bounty ultimately would be collected in 1882 in Jesse's St. Joseph, Missouri home. A newly recruited gang member, Bob Ford, put a bullet in the back of the outlaw's head as he was standing on a chair to dust a picture.

So, in 1868, the James brothers were not the notorious outlaws and dime-novel antiheroes they would someday be. There are several reasons why they might have been in California: one version cites the healing properties of the Paso Robles hot springs. At the end of his wartime service with savage Confederate guerrillas led by "Bloody Bill" Anderson (Jesse believed that Sheets had a hand in Anderson's death), Jesse had been grievously wounded with a bullet that hit him below a rib and punctured a lung, and his recovery was slow and painful. So the brothers may have come to California for Jesse's health. Another, more plausible, version had to do with Reconstruction-era politics in Missouri. The Civil War, in very real ways, continued in Missouri for years after it had ended at Appomattox. The state was split into factions that despised one another. Radicals supported Republican Reconstruction plans, including civil rights for former slaves; Conservatives opposed them; and diehard Confederate guerrillas, called "bushwhackers," fought pitched battles with civil authorities. The political scales tipped toward the Radicals in 1868 with the election of Republican Ulysses S. Grant. Radical Missouri governor Thomas Fletcher recruited a militia, many of whose members were former Union soldiers, ruthless and implacable, like the bushwhackers, to hunt down the unreconstructed rebel guerrillas, now common criminals.

Judge James R. Ross, a James descendant, at a 2002 family reunion front of a rural Paso Robles cabin said to be occupied by Frank and Jesse James in 1868–69. *Photo by Eric F. James, James Preservation Trust.*

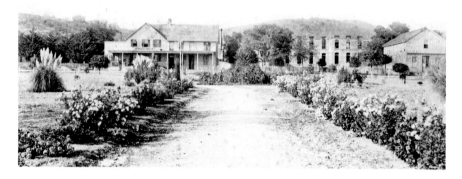

The original Paso Robles Inn, co-owned by Drury James. A larger inn is under construction at right. *San Luis Obispo County History Center.*

If anything, western Missouri was even unhealthier for Jesse James than his old bullet wound.

Their Uncle Drury was not entirely pleased when they appeared on his ranch near Paso Robles. Family tradition has it that he allowed them to stay so that Jesse could heal, and they spent their time playing at cowboy on his La Panza Ranch. Drury James's vaqueros were unimpressed with the brothers' skills at roping but probably withheld their laughter. Jesse was a superb horseman and was not averse to showing off his accuracy with an 1860 Colt Army revolver. During their months here, the brothers probably traveled to San Francisco and to the Gold Country in an unsuccessful search for their father's grave. Drury, meanwhile, was taking a new direction in his own life: his wife was expecting a baby and he had decided to become a townsman. He ultimately would sell his ranch, become co-owner of the Paso Robles Inn and, in the process, emerge as one of the most respected men in the county. It did his reputation no harm when, in early 1869, he bought his nephews passage on a ship headed east, around Cape Horn. Near the end of that year, Jesse would put two bullets into the body of John Sheets in the Daviess County Savings Association Bank in Gallatin, Missouri.

In the 1890s, a new criminal gang, ardent admirers of the James brothers, would begin robbing midwestern banks. One of the factors that makes the Dalton brothers so fascinating was their geographical and family connection to Jesse and Frank James. The Daltons settled in western Missouri, not far from Clay County, and Lewis, the Daltons' father, married Adeline Younger, the aunt of Bob, Cole and Jim Younger, who in turn were cousins to Frank and Jesse and members of their gang. All three Younger brothers were wounded and then captured after Jesse's disastrous 1876 raid on a bank in Northfield, Minnesota.

But unlike their Younger cousins, the Daltons entered young manhood as police officers. Frank Dalton was a deputy marshal operating out of Fort Smith, Arkansas—headquarters, as well, for Charles Portis's Rooster Cogburn in the classic picaresque novel *True Grit*—and his brothers Bob and Grat followed in Frank's footsteps. Frank was killed in a shootout with criminals in 1887, and it was Bob who decided to form the gang, including Grat; another brother, Emmett; Dick Broadwell; George "Bitter Creek" Newcomb; and others. The gang, unfortunately, became best known for an attempted robbery of two banks simultaneously in 1892 Coffeyville, Kansas. If anything, it was a greater disaster than the James-Younger gang's Northfield raid. Once they'd detected the robbery in progress, the citizens of Coffeyville began running home for their pistols, rifles and shotguns; once armed, they let the Dalton gang have it. Four of the outlaws were killed, including brothers Bob and Grat.

There was another Dalton brother not present that day in Coffeyville. Bill Dalton, who arrived midway in the family of fourteen children that Lewis and Adeline raised, was doing what the James brothers had only pretended to do. He was a real cowboy, a rancher who lived north of Paso Robles. (Yet another brother, Littleton, ran a saloon nearby.) One habit that might have set Bill apart from his neighbors was a fondness for target practice. The sound of distant gunshots would have accelerated from October 1891 until early 1892—the noise would have made focusing on the sermon at the nearby Estrella Adobe Church difficult on Sundays—when Bill's brothers visited him on his ranch. During their stay in the North County, the brothers were suspected of local crimes, as well. Grat was actually arrested for armed robbery in Tulare County but escaped. Unfortunately for Grat, he escaped in time to accompany his brothers to the carnage in Coffeyville, Kansas.

Somehow, even the grisly photographs of his well-ventilated brothers on the Coffeyville boardwalk were not enough to persuade Bill Dalton

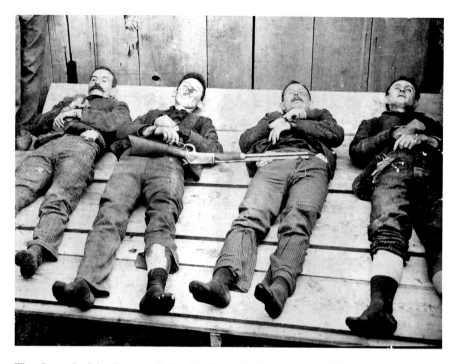

The aftermath of the disastrous Coffeyville, Kansas bank robberies in 1892: dead gang members (*left to right*) Bill Powers, Bob Dalton, Grat Dalton and Dick Broadwell. *Library of Congress.*

to continue a peaceful life on his ranch. He decided, instead, to leave California to reunite the gang that his brother Bob had assembled and then led to slaughter. Bill's outlaw career lasted only until 1894. When cash from a bank robbery in Longview, Texas, was linked to him, a marshal's posse, made more enthusiastic by their confiscation and sampling of a contraband shipment of whiskey, tracked him down to an Oklahoma ranch owned by a Dalton friend named Houston Wallace. Only two posse members remained sober enough to creep up to the ranch house, where they observed a man playing with four children. A little girl returning from fetching the Wallace family milk cow saw the watching men, ignored them and tied the cow up in the front yard. When she said something to the man playing with the children, he disappeared into the ranch house. He came diving out a back window and ran, firing a revolver in the general direction of the two men who were hunting him. They replied with a deadly volley from their Winchester rifles. When they approached the apparently lifeless body, it wasn't. Bill Dalton looked at them, smiled and died.

The Estrella Adobe Church, where services might be disturbed by the Dalton brothers' target practice nearby. *Wikimedia.*

Emmett Dalton looks like the outlaw he once was in this photograph, autographed for San Luis Obispo County Sheriff Jess Lowery in the late 1920s. *Tim Storton Collection.*

123

If the Dalton Gang's days were over, the brothers came back, in a way, to San Luis Obispo eighty years after Bill's death. The Eagles played in concert at Cuesta College—at five dollars a ticket, and with guest performer Neil Young—in March 1974. A year earlier, they had released a concept album, one that didn't sell well at first but was widely and critically praised. It was called *Desperado*, and it told the story of the Daltons to a new generation, including young people who lived where the brothers had once punctuated their visits to Bill's ranch with pistol practices that so flagrantly violated the Sabbath.

Bill Dalton may have been noisy, but he was a good host. Sheriff Ed O'Neal stopped by his ranch in 1892, running down rumors attached to a series of train robberies that might have involved Bill's brothers—including the robbery that got Grat convicted. Not only did Bill plead innocence, but he also invited Ed to spend the night to prove his good will. Ed and his partner, a railroad detective, accepted the hospitality and slept, one presumes, soundly on the ground floor of Bill's ranch house. Hidden on the floor above them were two Daltons, sleeping less soundly with blankets, pillows and a large assortment of pistols, in case Sheriff O'Neal got wise. Fortunately for him, he didn't.

By now, though, the Daltons had competition in a new pair of outlaws with a fondness for robbing Southern Pacific trains. There were few things—drought, hoof-and-mouth disease and property taxes come to mind—that San Luis Obispo County farmers and ranchers hated more than the railroad, most especially the Southern Pacific. The SP was so immensely powerful and so arrogant, and its monopoly on California so unshakeable, that even a soul as cultivated and sagacious as Blue Star, the theosophist who founded the Temple of the People in Halcyon, referred to the Southern Pacific as "that beast." Frank Norris's 1901 novel *The Octopus*, a thinly veiled attack on the SP, ends with the character representing the railroad tripping over the coaming of a ship's hatch, falling into the cargo hold and suffocating under an immense flood of California wheat, India-bound, that buries him alive. It must have been a passage that some California farmers, including many wheat-growers in the North County, read over and over again.

In the 1890s, farmers still had not forgotten a May 1880 shootout at Mussel Slough in Fresno County. When the federal government granted SP tracts

of land along its right of way to finance railroad construction, farmers who had homesteaded that land for years suddenly found they had to buy it back from the railroad at exorbitant prices. Their resentment, and the railroad's determination to lay track, climaxed with a forty-five-second gunfight near Hanford between authorities and farmers who were outraged that one of them was being evicted from his farm. The farmers were outgunned; four of them were killed, but they in turn shot and killed two SP representatives. It was this incident that would inspire Norris to write his muckraking novel about the railroad.

For San Luis Obispo County grain farmers, the monopoly represented by the Southern Pacific was challenged only briefly in the 1880s by the appearance of a competitor in Southern California, the Santa Fe, but the two giants agreed to cooperate instead and fixed freight rates, resisting repeated attempts by the California rail commission to reduce those rates. In 1891, farmers in the San Miguel area pleaded with the commission for a 30 percent reduction in freight rates. "It is impossible," they said in their petition, "for the farmer to pay the current expenses of his businesses and procure the necessaries of life for his family." Their efforts failed.

In response, local farmers became some of the strongest supporters of the insurgent Populist Party, dedicated to bimetallism (a currency based on silver as well as gold would make borrowed money, increasingly necessary as agriculture became mechanized, far cheaper for farmers), breaking up monopolies and the regulation of freight rates. Although never more than minority candidates, both Populist presidential nominee James B. Weaver, in 1892, and gubernatorial nominee J.V. Webster, a San Luis Obispo farmer (and a former Kearneyite), in 1894, did well in San Luis Obispo County, outperforming their statewide vote percentages. Webster, for example, won 18 percent of the statewide vote in 1894 but won 33 percent in his home county. Michael Magliari, a history professor at California State University–Chico, found a powerful evidence of the popularity of Populism where the railroad monopolized transport, as was the case in San Luis Obispo County. Populist candidates performed poorly in counties in the Sacramento Delta, where farmers had alternatives to the Southern Pacific in water transport.

Far less momentous than the Populist movement and the plight of California farmers was the small tragedy of a Southern Pacific employee named John Sontag. Sontag, a Minnesotan, came to California in 1878 and began working as a Southern Pacific brakeman. At the same time, Chris Evans, a young Canadian who had moved to the United States in the Civil

The height of the Populist Party's power came in 1896, when William Jennings Bryan ran on a joint Populist/Democratic ticket. Republican William McKinley won the presidency. *Library of Congress.*

War years, arrived in San Luis Obispo and lived in the North County for four years, working as a miner. Evans's time here would have coincided with a small gold strike at La Panza, northeast of Pozo, that would eventually yield about $100,000 in ore. Evans's mining career ended, and he took up farming near Visalia and started a family there. John Sontag's career with the Southern Pacific ended, in corporate behavior typical of the Gilded Age, when he was hurt on the job—he was partly impaled on an iron rail—and the company fired him.

The two men met in 1887. Sontag, the wronged employee, and Evans, the San Joaquin Valley farmer, shared antipathy for the railroad. Mrs. Evans's uncle had evidently been one of the farmers who had lost his land in the struggle that culminated in the Mussel Slough gunfight. Evans gave Sontag a job on his farm, but the synergy of two men who liked each other but despised the Southern Pacific was too much to resist. Their first robbery was in 1887, near Pixley, and it was spectacular: they blew up the express coach on the Southern Pacific No. 17 passenger train, recovered $5,000 from the debris and disappeared. A second robbery, in January 1890, resulted in a $20,000 loss for the Southern Pacific; a passenger was shot to death during the robbery. Explosives were used again in a third robbery in August 1892, one described by Tulare County historians Eugene L. Menefee and Fred A. Dodge in 1913:

Right: Chris Evans after his capture, with evidence of his wounds from the Stone Corral fight. *Tim Storton Collection.*

Below: A mortally wounded John Sontag after the Stone Corral fight.
Tim Storton Collection.

The robbers mounted the tender of the engine and, covering the engineer and fireman with arms, compelled a stop. A stick of dynamite was placed on the piston rod and exploded. The engineer jumped and ran, making his escape, but the fireman was held by the robbers, who marched back by the side of the train, firing to intimidate passengers. When the express car was reached, a stick of giant powder was placed on the sill of the door, and in exploding, wrecked the car, breaking three doors, blowing a hole in the roof, and scattering the contents in every direction.

The messenger, George D. Roberts, was lying on the floor, rifle in hand. The shock of the explosion threw him across the car, dislocated his shoulder and rendered him senseless for a few moments. As soon as Roberts recovered his faculties he stuck his hands through the open door to announce that he gave up. The robbers went into the car and compelled him to open the safe. Three bags of coin containing between $10,000 and $15,000 were taken.

If messenger Roberts did the prudent thing in giving up, Sontag and Evans would have been wise to follow his example. They were hunted now by mercenary posses shunted around the San Joaquin Valley on special trains run by the Southern Pacific. In June 1893, law enforcement was tipped off that the two outlaws were to rendezvous at a place called the Stone Corral, near Visalia. A four-man posse waited patiently for eight days for the train robbers to appear. When they finally did, bullets started flying as soon as Sontag and Evans dismounted. The two hid behind a mound of straw and manure and attempted to return fire, but both men were badly wounded. One bullet wound would cost Evans an eye; he also was hit in the arm. Sontag's shoulder was shattered by a bullet, and he told his partner that he was a dead man. So Evans, with Sontag's encouragement, said goodbye. Sontag began firing to cover Evans's escape in the dark, then held out all night. He was finally captured the next morning.

The wound to Sontag's shoulder was fatal; he would die of complications from it, including tetanus, three weeks later. Evans made it as far as a nearby farmhouse, where authorities found him asleep in an upstairs bedroom. In addition to losing his eye, he would lose his left arm, as well. After a temporary jail escape and flight, Evans would finally do seventeen years in Folsom. He was released from prison in 1911, on the condition that he leave California. Evans died in Oregon in 1917, denying that he had ever been a train robber.

The governor who ordered his release was Hiram Johnson, a Republican Progressive, like Theodore Roosevelt, who won the 1910 gubernatorial race in large part because of his promise to curb the power of the Southern Pacific Railroad.

ROARING TWENTIES

Because San Luis Obispo County is midway between San Francisco and Los Angeles, it has always been a natural stopping point for travelers or vacationers who might stay awhile to go clamming in Pismo Beach or sink contentedly into the hot springs in Paso Robles. It was natural, too, that the first recognized motel—"motor hotel"—was built in San Luis Obispo in 1925, just north of town, not far from the site where Walter Murray's ranch house once stood. It was, of course, a brilliant concept, since the number of automobile owners in America had tripled just between 1920 and 1923, and the place had a certain charm, with Spanish Mission-style architecture and a restaurant with a reputation for excellent steaks.

Dinner was ruined on Thursday night, December 27, 1928, by a masked gunman who took $125 from guests in the dining room and another $93 from the hotel clerk. The image of the county sheriff's department was at least temporarily ruined when both the clerk and a bellhop identified the robber, later arrested, as former Undersheriff Emmett Donnelly. Donnelly retained attorney Albert Nelson, the one-time prosecutor who had convicted Willie Luis, and in Donnelly's February trial, Nelson was masterful, questioning the accuracy of the eyewitnesses' description of the robber and pouncing on contradictions in their testimony. Donnelly was acquitted, to great joy from his friends and family in the courtroom, but his troubles weren't over. In 1934, he survived an automobile crash into a telephone pole when he swerved to avoid a file of National Guardsmen walking along the road in Shell Beach. In 1937, he was evidently drunk

The Motel Inn, San Luis Obispo, late 1920s. *The Huntington Library.*

when he hit two cars in downtown San Luis Obispo and fled through town, with city police in pursuit, at speeds up to eighty miles per hour. One of the officers giving chase fired three shots at Donnelly's car as it bounced onto the grounds of the high school. The patrolman intended to hit Donnelly's tires, but one shot hit Donnelly instead, wounding him in the neck and ending the chase. He was pulled from the car, hospitalized and recovered, only to be fined $200 by police court judge Richard Harris. It was a sad stretch of life for Emmett Donnelly.

Earlier in the 1920s, another San Luis Obispo hotel figured in one of the most notorious scandals of a frequently scandalous decade. Aimee Semple McPherson was then one of the most famous evangelists in America and the founder of the Foursquare Gospel Church, today 1,400 churches strong. She was a marvelous actress—advised in part by friend Charlie Chaplin, her sermons were framed by elaborate stage settings, and she dressed in various costumes, as a little Dutch girl, for example, complete with wooden sabots. The milkmaid-revivalist portrayed by Jean Simmons in the film production of *Elmer Gantry* was based on Sister Aimee, as was a character in Nathanael

Evangelist Aimee Semple McPherson. *Library of Congress.*

West's dark novel, *The Day of the Locust.* She was flamboyant, dramatic, attractive and enormously successful.

She also was known for her good works. In the 1925 Santa Barbara earthquake, she took the microphone away from a stunned radio broadcaster and pleaded for immediate aid for the stricken city. Convoys of food, blankets and emergency supplies were soon on their way. She was insistent on integrating her congregation, a courageous policy at a time when the

133

power of the Ku Klux Klan, even in California, was at its height. She ran a commissary for the homeless out of her Angelus Temple that was shut down briefly in 1932 when a still was discovered in the kitchen.

In May 1926, Aimee disappeared. Presumed drowned off Venice Beach, a search that included the California National Guard failed to turn up any trace of the beloved Aimee's body. She was gone.

For a month.

In June, she turned up, disheveled and disoriented, in the town of Agua Prieta, on the Mexican border, revealing that she'd escaped from an adobe house in Mexico where she'd been held captive by two kidnappers named "Steve" and "Rose." She was hospitalized in Douglas, Arizona, and the newspaper accounts of her survival were welcome news to her followers. As many as fifty thousand Angeleños were waiting for her when her train arrived from Arizona.

As it turned out, Aimee's story was a fabrication. When her account began to come under scrutiny, she brazenly, and foolishly, demanded a grand jury investigation whose focus soon became Aimee herself.

Enough character witnesses appeared on her behalf to muddle the case, which was eventually dismissed, but this is what most likely happened: Aimee

HOTEL ANDREWS
San Luis Obispo, Cal.

Aimee and her lover, a sound engineer, spent the night at San Luis Obispo's Hotel Andrews. *San Luis Obispo County Regional Photograph Collection, Special Collections and Archives, Cal Poly State University–San Luis Obispo.*

had an affair with a former employee, a radio engineer named Kenneth Ormiston, and the dates of her disappearance coincided with his rental of a seaside cottage in Carmel.

The plot thickened when Ormiston was identified as the male half of a couple that had registered as "Mr. and Mrs. Gibson"—the female was heavily veiled—when they checked in at the Hotel Andrews in San Luis Obispo shortly after Aimee's alleged drowning. The Andrews, which stood on the corner where the San Luis Obispo City-County Library today stands, reached the height of its fame in a twenty-four-hour cycle of national newspaper headlines.

Aimee had reached the height of her fame as well. She continued to preach until her death in 1944, but the luster was gone; infighting between Aimee and her mother, Mildred Kennedy, took both a personal and business toll on the evangelist. When her body was found in an Oakland hotel, a bottle of Seconal was found nearby and the coroner's inquest suggested that both an accidental overdose and kidney problems figured in Sister Aimee's death.

Admirers sent eleven truckloads of flowers, valued at $50,000, to her funeral at the Angelus Temple. She is buried, along with so many other Hollywood stars, at Forest Lawn in Glendale.

Eleanor Walling was evidently an enchanting little girl—one can easily visualize her in a blouse with a sailor's collar, with a big bow in her hair, like L. Frank Baum's Dorothy. She was also a show business talent and a ticket-office draw for her father, a small-town impresario who owned the Lompoc Opera House, the setting for a 1912 rally for Bull Moose candidate Theodore Roosevelt. On that day, Eleanor enchanted the *Lompoc Journal*, too. The paper notes that "the program was introduced in a most pleasant manner by little Eleanor Walling, daintily clad and draped in a flag, stepping to the front of the stage and with her little violin leading the orchestra in the Star Spangled Banner in a way that carried the audience away."

Eleanor was eight years old. Her mother had died young, but either she or J.O., Eleanor's father, had bequeathed the little girl with extraordinary musical gifts. She was an actress as well as a violinist, appearing in her father's plays, including *The Moonshiner's Daughter* and in the title role in *Editha's*

Burglar, which "proved a hummer," according to the *Journal*. Sometimes she shared the bill with silent films like *Tobacco Mania*.

Eleanor, born in Oregon, San Luis Obispo or England, depending on the source, had, by World War I, joined her father and siblings in a new enterprise: the Walling Orchestra entertained at concerts and at dances in a roadhouse owned by J.O. near Avila Beach. She is said to have lived in Arroyo Grande for a short time. But she soon struck out on her own, for the vaudeville circuit, the story went.

Pretty Eleanor was twenty years old and just as enchanting when she played the violin for her guards at the Kern County Jail in the spring of 1924. She'd been accused, with a male accomplice, of robbing a Taft bank of $5,700. A revolver discharged during the robbery. Eleanor allowed that it might have been hers, but she wasn't clear on who was holding it at the time. Then, after that, she suggested that she hadn't been in the bank at all. Her story changed as often as her birthplace.

The Taft State Bank, today a popular sports bar and grill. *Courtesy of the Bank Sports Lounge, Taft, California.*

But in the robbery's immediate aftermath, she wasn't suggesting anything. Detectives from both the sheriff's office and the Los Angeles Police Department grilled her for two days. They got nothing. "EFFORTS OF POLICE OFFICERS AMUSE GIRL HELD IN ROBBERY," a headline read. Her hair was cut short, like a flapper's, so she became the "Bobbed-Hair Bandit." "PRETTY ELEANOR SMILES AT OFFICERS AS THEY QUESTION HER," another headline announced. She decided to let her hair grow, now that she had the time. She pleaded not guilty in April.

She changed her plea in May. She might have been threatened by a defense witness called to testify on behalf of Bill Crockett, her accomplice, the man suspected of planning the bank robbery. The prospective witness, a Folsom inmate, was ready to testify that Eleanor had been with him when he had shot a "Dutchman" during an armed robbery in Los Angeles. He complained later that the government paid doughboys thirty-two dollars a month to kill Dutchmen, but they gave him twenty-nine years—and he'd just wounded his. And his conviction came because Eleanor had turned state's evidence. Now, he suggested, she'd been much more than an innocent bystander.

Meanwhile, the papers were reporting that she had been one of the robbers who burst into the Taft State Bank on March 13, 1924, at 9:00 a.m., helping to round up customers and tellers. She'd been dressed as a man. She continued to dress that way—"her crossed legs garbed in khaki and long hiking boots"—after her arrest.

Newspaper stories hinted that she wasn't innocent in other ways. Both the defense witness and Bill Crockett were infatuated with her. So were the deputies at the Kern County Jail.

But by the time of the trial for the robbery, a reporter wrote, "gleaming hatred" appeared in Crockett's eyes at the mere mention of her name. Crockett was unlucky in love and inept in crime. His mask had slipped as he herded the bank's occupants into the vault, so a teller on the witness stand identified him without hesitation. And while they made away with $5,700—nearly $80,000 today—they overlooked another $30,000 nearby.

And not only had Eleanor confessed, but she also led the detectives to the cash. They found $1,000 buried under two railroad ties on General Petroleum property outside of Taft; another $1,800 was buried at the base of a telephone pole.

Eleanor distanced herself from the robbery on the witness stand, when "every pair of eyes in the courtroom was directed at her," as a Bakersfield newspaper reporter wrote. The reporter, who had an eye for fashion,

wrote that Bill Crockett's eyes gleamed, with him probably wishing he could burn holes in Eleanor, through that "sponged blouse with a man's collar, about which was knotted a shoestring 'sheik tie.' Over her blouse she wore a brown and fawn-colored barred sports vest. A brown full silk skirt completed her ensemble."

According to Eleanor, she hadn't been at the bank at all. That was another man, named Ray. All she'd done was to burn their clothes after and change the license plates on their car. Oh, and she buried the revolvers somewhere between Taft and Fellows.

Eleanor was giving one of her last performances for an audience of any size. They were rapt. She went to prison anyway.

Ironically, Bill Crockett was acquitted, only to be convicted later of a second robbery. He did time and so did two of his brothers, one a thief and the other a forger who, according to a family history, would do the hardest time of all, on Alcatraz. Until Taft, Eleanor's record was a clean one, with one exception. In 1920, she started an eighteen-month term in a Ventura reformatory. She hadn't played the vaudeville circuit. She'd run away from home.

Her San Quentin term was five years to life. The "Bobbed-Hair Bandit" shared a cell with Clara Phillips, "The Girl with a Hammer," after her murder weapon of choice. She believed her husband had taken a lover and had asked the hardware store clerk, as she was speculatively hefting the hammer, if he thought it was heavy enough to kill a woman. He guessed it was. He was right.

Eleanor had been an actress, but Clara was a drama queen. She tried to escape twice and failed both times, once breaking out of a town jail, once slashing her wrists with a razor blade she borrowed from a San Quentin matron. Eleanor did her time quietly. After her parole, she lived in San Francisco, in the Noble Hotel, on a narrow block of Geary Street. The 1930 census lists her occupation as "musician."

Two years after that, the *Oakland Tribune* reported that she'd been questioned and released for a bank robbery in the city. Some San Francisco police detective must have been disappointed, because he'd certainly done his homework. It must have looked like a good collar. The armed robbers had been two women, dressed as men.

When Al Capone stopped briefly for a game of billiards at the Waldorf Club in Pismo Beach—today, Cool Cat Cafe on Pomeroy Avenue—in December 1927, he needed the relaxation. Chicago was a tough place, and he had never seen the beautiful California coast before. It was a business vacation, too, because the San Luis Obispo coast's remoteness made it ideal for big-time bootleggers, like Al Capone, or smaller ones, like O.T. Buck, the owner of what is today McLintock's in Shell Beach, to smuggle liquor ashore during Prohibition. Liquor would be brought onshore by small fishing boats or speedboats from bigger ships farther out at sea, and among the favored places for rumrunners were San Simeon, Spooner's Cove in today's Montaña de Oro State Park and Cave Landing, today's Pirate's Cove, near Avila Beach. But Capone's stay here, on the coast that was so ideal for his business, would be brief. When he returned to Los Angeles, Police Chief Jim Davis ordered the twenty-eight-year-old mobster escorted onto the first available eastbound train. Capone returned to Chicago to resume his career, which would include the St. Valentine's Day hit on the Bugs Moran gang little more than a year later.

Mattie's Restaurant and Tavern, 1940. O.T. Buck had previously owned the property; he was reputed to be the liquor supplier to William Randolph Hearst's San Simeon estate. *The Huntington Library.*

Of the nearly thirty thousand residents of San Luis Obispo County in 1930, many were violating Prohibition in far less violent ways than Al Capone. Young Charlie Froom, whose family's ranch stood near the intersection of Highway 101 and Los Osos Valley Road, could pick up ten dollars for helping bootlegger truckers free their vehicles when they got stuck in the mud on the run from Spooner's Cove to the highway. The venerable Sauer Adobe, near Mission San Luis Obispo, was owned by a woman named Victoria Duchi, who evidently ran a speakeasy on the site. County residents might be able to look the other way for Duchi, but that wasn't the case when junior and senior boys began showing up intoxicated for their classes at Arroyo Grande Union High School in 1922 after having purchased liquor at "a dance hall resort" in Pismo Beach. Will C. Wood was the state superintendent of instruction, and when he heard about the incident, his outrage could be felt all the way from Sacramento to San Luis Obispo County. In July, twenty-seven Prohibition agents staged a series of raids aimed at the bootleggers who were selling alcohol to the Arroyo Grande boys.

At the time of the 1922 raid, the fight to enforce Prohibition was largely fought onshore. Efforts to intercept the rumrunners at sea were laughable. The Coast Guard could muster only two ships to patrol the California

Arroyo Grande Union High School, then located atop Crown Hill, where upperclassmen began showing up to class inebriated in 1922. *South County Historical Society.*

coast. *Vaughan* was an aging World War I sub-chaser, and the cutter *Tamaroa* was so painfully slow, with a maximum speed of ten knots, that it was nicknamed "the sea cow." After 1926, the Coast Guard's chances improved with the deployment of eight faster seventy-five-foot cutters, called "wasps," but the newer ships had to cover the coast from San Luis Obispo County to the Mexican border, so they were spread thin.

Law enforcement officers in San Luis Obispo County were few in number as well. Two county sheriffs—Charles Taylor, who would be killed in an automobile accident in 1929, and Jess Lowery—along with a future sheriff and federal revenue agent, Murray Hathaway, figure in a parade of arrests featured in San Luis Obispo newspapers in the 1920s and into the 1930s. Many of the arrests resulted in fines assessed by the local police court, and small-time bootleggers seemed undeterred by them. Joseph R. Robasciotti ran a "soft drink place" on Monterey Street in San Luis Obispo that evidently served harder stuff. He was arrested in 1924, 1927 and 1929 but had no qualms about applying for a new business license in between arraignments. It was the out-of-towners who were a more serious threat. Murray Hathaway, backed up by local officers, exchanged gunshots with bootleggers in 1925 on the coast between San Simeon and Cambria. No one was hurt, but Hathaway arrested five men, all from Los Angeles or San Francisco, and confiscated two hundred cases of liquor, probably scotch whisky, the most common product that came south from Canada. The next year, bootlegging turned deadly when authorities discovered the body of a local butcher, Gus Fisher, on a remote stretch of beach near Oceano. They suspected that he was surf fishing when he was shot by a gang waiting for a shipment of liquor to come onshore.

One of the most spectacular arrests during Prohibition came near Pismo Beach. Sheriff Jess Lowery pulled over a suspicious truck on Highway 101. When he began to push aside the lumber that made up driver J.F. Kirk's load, he found two hundred five-gallon jerricans filled with what one newspaper called "high proof whiskey" underneath. (Lowery apparently had better luck in holding on to the liquor than had his predecessor, Sheriff Taylor, who had to admit that one hundred bottles of confiscated alcohol had disappeared from a bull pen in the county jail in 1923.) In September 1932, on the eve of Franklin Roosevelt's election and the repeal of Prohibition, one of the last arrests of the era was of a big fish: Pico Cornero, the younger brother of mobster Tony Cornero, was arrested and $25,000 in liquor seized in Cayucos. Cornero was unfazed. He was arrested again, north of Santa Barbara, just two months later, and

Two Prohibition-era San Luis Obispo police officers pose with a squad car in front of Mission San Luis Obispo. *San Luis Obispo County Regional Photograph Collection, Special Collections and Archives, Cal Poly State University–San Luis Obispo.*

Above: San Luis Obispo County sheriff Jess Lowery with the contraband liquor he confiscated near Pismo Beach. Tragically, Lowery would take his own life in 1934. *Tim Storton Collection.*

Left: Jess Lowery's badge. *Tim Storton Collection.*

in between Pico's arrests, another brother, Frank, was arrested in a Los Angeles warehouse raid that intercepted $67,000 in liquor intended for celebrating the Christmas holidays.

Prohibition would end officially in December 1933, and in the meantime, the newly inaugurated FDR signed the "beer bill" in March, permitting the sale of beer and wine, so law enforcement officers were finally freed from chasing bootleggers and could turn to fighting other crimes. Sheriff Lowery wouldn't have to wait long for crime to come to him. In what must have seemed a revival of the days of Pio Linares or the Daltons, in July 1933, a See Canyon dairyman came riding on horseback into a service station on Lower Higuera in San Luis Obispo. Armed with a shotgun, he announced that he was in town to kill Chief of Police Harry Payton.

It soon became apparent that the horseman, Joe Callaway, was mentally disturbed and that his beef with the police chief was a fantasy. But that left the problem of the shotgun. Asked by a sheriff's deputy to drop the weapon, Callaway replied that he would do so as soon as he was dead. He then began to trot up Los Osos Valley Road, the same road where Dorothea Lange would photograph her cowboy six years later, with two motorcycle officers in low-speed pursuit. When one of officers opened fire on Callaway's horse and wounded it, the armed man vaulted off and disappeared into the tree line, literally headed for the hills. A National Guard artillery unit was on maneuvers nearby, and attempting to be helpful, the men loaned the gathering police forces the only live ammunition they had: three gas bombs. Sheriff Lowery then led a manhunt into rugged, mountainous See Canyon that lasted two days before it was called off. Callaway, for all his Wild West fierceness, was indeed a sick man and was soon reported to be in Oakland and in the care of family members there. Lowery and his deputies had done their duty, the excitement died down once Callaway was found and, best of all, no one was hurt during the manhunt up in See Canyon. There were no more outlaws hiding in the hills of San Luis Obispo County.

BIBLIOGRAPHY

Angel, Myron. *History of San Luis Obispo County, California.* Oakland, CA: Thompson and West, 1883.

Arroyo Grande Department of Public Works. "The Arroyo Grande Hoosgow Jail." Memorandum, City of Arroyo Grande, California, 2014.

Bakersfield Californian. "Alleged Bank Robbers to be Arraigned at Taft Tomorrow." March 18, 1924.

———. "Girl Born in San Luis Obispo, Remembered There." May 8, 1924.

———. "Girl Relates Vivid Story of Robbery by Bandits." June 20, 1924.

———. "Officers Accuse Eleanor Walling in SF Holdups." September 21, 1932.

Beckwourth, James Pierson. *The Life and Adventures of James P. Beckwourth, Mountaineer, Scout, and Pioneer, and Chief of the Crow Nation of Indians.* New York: Harper and Brothers, 1856.

Beebe, Rose Marie, and Robert M. Senkewicz. *Testimonios: Early California Through the Eyes of Women.* Berkeley, CA: Heyday Books, 2006.

"Biographical Notes: John Charles Fremont." Wandering Lizard California. Accessed December 10, 2016. http:/www.inn-california.com/articles/biographic/jcfremontbio1.html.

Boessenecker, John. *Bandido: The Life and Times of Tiburcio Vasquez.* Norman: University of Oklahoma Press, 2010.

———. "California Bandidos: Social Bandits or Sociopaths?" *Southern California Quarterly* 80, no. 4 (Winter 1998): 419–34.

Brantingham, Barney. "A Devil on Horseback." *Santa Barbara Independent,* June 21, 2012.

Burnett, Claudine. *Prohibition Madness: Life and Death in and Around Long Beach, California.* Bloomington, IN: AuthorHouse, 2013.

"The California Gold Rush." Eyewitness to History. Accessed December 10, 2016. http://www.eyewitnesstohistory.com/californiagoldrush.htm.

Castro, Francisco. "Undated Note to San Luis Obispo Board of Supervisors." San Luis Obispo, California, Tim Storton Collection.

Clark, Louise M. "Local Lore from San Luis Obispo." *Western Folklore* (October 1949): 297–303.

Daily Alta California. August 16, 1851.

———. "From San Luis Obispo: Great Excitement—The Execution." October 11, 1853.

Dale, Lyle A. "Rough Justice: Felony Crime and the Superior Court in San Luis Obispo County, California, 1880–1910." *Southern California Quarterly* 86, no. 2 (Summer 1994): 195–216.

Dana, Richard Henry. *Two Years Before the Mast.* New York: New American Library, 2009.

Dana, Rocky, and Marie Harrington, eds. *The Blond Ranchero: Memories of Juan Francisco Dana.* Arroyo Grande, CA: South County Historical Society, 1999.

"Declaration of Joseph Lynch." Archives, Mission Santa Barbara, Santa Barbara, California, 1848.

"Declaration of Peter Remer." Archives, Mission Santa Barbara, Santa Barbara, California, 1848.

Ditmas, Madge C. *According to Madge.* Arroyo Grande, CA: South County Historical Society, 1983.

———. "Filipinos Increasing Unemployment Problem." *Arroyo Grande Valley Herald-Recorder*, March 20, 1933.

Edwards, Harold L. "Dick Fellows." Old West Outlaws. Accessed December 26, 2016. http://www.jcs-group.com/oldwest/outlaws/fellows/html.

Federal Bureau of Investigation. "Uniform Crime Reports." Accessed December 12, 2016. https://www.therace.org/2016/chicago-gun-violence-per-capita-rate.

"Gold Fever! San Francisco." Oakland Museum of California. Accessed December 12, 2016. http://explore.museumca.org/goldrush/fever15.html.

Gonzales-Day, Ken. *Lynching in the West, 1850–1935.* Durham, NC: Duke University Press, 2006.

Gordon, Thomas J. "Joaquin Murieta: Fact, Fiction and Folklore." Master's thesis, Utah State University, 1983.

Hall-Patton, Joseph. "Pacifying Paradise: Violence and Vigilantism in San Luis Obispo." Master's thesis, California Polytechnic State University, 2016.

Harvey, Steve. "L.A. Tells Gangster Al Capone to Get Lost." *Los Angeles Times*, February 6, 2011.

Hodgson, Mike. "Death Watch Commemmorates Walker." *Five Cities Times-Press-Recorder*, April 2, 2004.

Hoving, Gary L. *Journey of Justice.* San Luis Obispo, CA: San Luis Obispo Historical Society, 2000.

James, Eric. "Jesse James Family Members Visit Jesse's Cabin in Paso Robles." Jesse James Family Reunion, December 20, 2014. Accessed January 7, 2017. http://ericjames.org/wordpress/2014/12/20/jesse-james-family-reunion-2002-video-pt-8.

Johnson, David A. "Vigilance and the Law: The Moral Authority of Popular Justice in the Far West." *American Quarterly* 33, no. 5 (Winter 1981): 558–86.

Jones, Fred, interview as remembered by Michael Shannon and Bruce Gregory. Remarks to Branch Elementary School Students, 1958.

Kamiya, Gary. "Demoagogue Editor Fired up Readers, Revolutionaries." sf.gate.com, July 15, 2014. Accessed December 22, 2016. http://www.sfgate.com/bayarea/article/Demagogue-editor-fired-up-readers-revolutionaries-5646921.php.

King, Nathan. "Inquest Held Aug. 22, 1878 upon the Body of Francisco Castro, Deceased." Coroner's inquest, San Luis Obispo, California, San Luis Obispo County Coroner, 1878.

———. "Inquest Held Aug. 21, 1878, upon the Body of Thomas Jones, Deceased." Coroner's inquest, San Luis Obispo, California, San Luis Obispo County Coroner, 1878.

Krieger, Dan. "Bringing Law and Order to the Old West." *San Luis Obispo Tribune*, February 13, 2000.

———. "Did Legendary Bandit Escape SLO Posse's Clutches?" *San Luis Obispo Tribune*, May 11, 2013.

———. "Ghost Stories from SLO County: The Ghost of Jesse James Lies Low in the Area." *San Luis Obispo Tribune*, October 24, 2014.

———. "Lynch Mobs Part of Area's History." *San Luis Obispo Tribune.* July 23, 2013.

———. "SLO County: Murder Capital." *San Luis Obispo Tribune*, June 23, 2013.

———. "Trek through SLO County Was a Risky Prospect." *San Luis Obispo Tribune*, May 19, 2013.

Lake County Archaeology. "The Immaculate Heart Dig." Accessed December 27, 2016. http://www.wolfcreekarcheology.com/ImacMedical.html.

Leonard, Ralph J. "The San Miguel Mission Murders." *La Vista Magazine*, June 1980.

Livingston, Phil. "The History of the Vaquero." *American Cowboy Magazine*. Accessed December 6, 2016. http://www.americancowboy.com/article/history-vaquero.

Lompoc Journal. "Moonshiner's Daughter Proves a Hummer." March 12, 1910.

———. "Progressive Rally." November 9, 1912.

Lovell, Julia. "The Opium Wars: From Both Sides Now." History Today, June 6, 2012. Accessed January 2, 2017. http://www.historytoday.com/julia-lovell/opium-wars-both-sides-now.

Magliari, Michael. "Populism, Steamboats, and the Octopus: Transportation Rates and Monopoly in California's Wheat Regions, 1890–96." *Pacific Historical Review* 58, no. 4 (November 1989) 449–69.

McGrath, Roger D. "A Violent Birth: Disorder, Crime, and Law Enforcement, 1849–1890." *California History* 76, no. 2 (2003) 27–73.

McKenna, Clare V. "Enclaves of Violence in Nineteenth-Century California." *Pacific Historical Review* 73, no. 3 (August 2004): 391–424.

Middlecamp, David. "Don Henley's Upcoming Visit Spurs Memories of SLO County's Desperados." *San Luis Obispo Tribune*, May 14, 2016.

———. "Motel Inn in San Luis Obispo, the World's First 'Mo-tel'." *San Luis Obispo Tribune*, December 24, 2014.

———. "Walter Murray Founds the Tribune." *San Luis Obispo Tribune*, August 12, 2009.

Morrison, Annie Stringfellow, and John H. Haydon. *History of San Luis Obispo County and Environs.* Los Angeles, CA: Historic Record Company, 1917.

Muncrief, Dennis. "The Killing of Bill Dalton." Rootsweb. Accessed January 8, 2017. http://www.rootsweb.ancestry.com/okmurray/stories/dalton/htm.

National Park Service. "Durgan Bridge." A History of Mexican Americans in California: Historic Sites. Accessed December 18, 2016. https://www.nps.gov/parkhistory/online_books/5views/5views5h31.htm.

Nevins, Allan. *Frémont, Pathfinder of the West.* Lincoln: University of Nebraska Press, 1993.

New York Times. "Exciting Scene in San Luis Obispo—Another Outlaw Hung." November 23, 1853.

Nolte, Carl. "Gold Rush Ship's Remnants Unearthed in Financial District." *San Francisco Chronicle*, November 14, 2016.

Oakland Tribune. "Bootleggers Sell Booze to Students." June 30, 1922.

———. "Former Sheriff's Deputy Held Bandit." January 11, 1929.

———. "Hijackers Suspectded of Murder on Beach." June 17, 1926.

———. "U.S. Indicts Two in Coast Rum Seizure." November 10, 1932.

———. "Woman Bank Robber Tells Cash Secret." May 2, 1924.

Ohles, Wally. *The Lands of Mission San Miguel.* Sanger, CA: Word Dancer Press, 1997.

Ord, Lieutenant Edward O.C. Letter to Colonel Richard B. Mason. Santa Barbara California, Mission Santa Barbara Archives, 1849.

Paddison, Joshua, ed. *A World Transformed: Firsthand Accounts of the California Gold Rush.* Berkeley, CA: Heyday Books, 1999.

Paz, Ireneo. *Life and Adventures of the Celebrated Bandit Joaquin Murrieta: His Exploits in the State of California.* Houston, TX: Arte Publico Publishers, 1999.

People vs. Luis. 1910. 158 Cal. 185 (Supreme Court of California, In Bank.).

Pitt, Leonard. *The Decline of the Californios.* Berkeley: University of California Press, 1966.

Price, John M. Letter to William G. Dana. Santa Barbara, California, Mission Santa Barbara Archives, 1848.

Radding, Jeffrey. "Early Murders." *San Luis Obispo County Bar Bulletin* (March–April 2013): 6–13.

———. "A Vital Determination." *San Luis Obispo County Bar Bulletin* (July–August 2009): 5–11, 34–36.

Redmon, Michael. "The Bandit Dick Fellows." *Santa Barbara Independent,* May 13, 2015.

———. "The de la Guerra Wedding." *Santa Barbara Independent,* June 28, 2011.

———. "Did Zorro Once Live in Santa Barbara?" *Santa Barbara Independent,* August 18, 2015.

———. "Question: What Was the Hide and Tallow Trade?" *Santa Barbara Independent,* November 8, 2017.

Ridge, Martin. "Disorder, Crime, and Punishment in Gold Rush California." *Montana: The Magazine of Western History* (August 1999): 12–27.

Rife, Ronald Edward. "Constructing Social Bandits: The Saga of Sontag and Evans, 1889–1911." Master's thesis, California State University, 2011.

Ross, Dudley T. *Devil on Horseback.* Fresno, CA: Valley Publishers, 1975.

Saari, David J. *Francis Branch: A California Pioneer from New York.* San Luis, CA: Central Coast Press, 2009.

Sacramento Daily Union. April 3, 1886.

———. "The Spanish Races in California." November 27, 1852.

San Francisco Chronicle. "End of a Tragedy." November 14, 1886.

———. "George Roberts Freed of Murder Charge." June 12, 1904.

———. "May Be Charged with Murder." March 30, 1904.

San Luis Obispo Daily Republic. April 1, 1886; April 2, 1886; April 10, 1886.

San Luis Obispo Daily Telegram. "Aged Rancher Found Dead." April 14, 1934.

———. "Aimee Searchers Here." June 2, 1926.

———. "Buck Pleads Not Guilty." January 16, 1934.

———. "City Council Will Survey Fire Risks." July 7, 1925.

———. "City Police in Raid on Liquor Ring." December 3, 1925.

———. "Donnelly Fined $200." April 23, 1937.

———. "Donnelly Not Guilty." February 12, 1929.

———. "Liquor Suspect Will Face Jury." January 25, 1929.

———. "Mystery Couple Were Here." June 1, 1926.

———. "No Complaint Callaway." July 15, 1933.

———. "Rebel Flag of Chinese Is Unfurled over the Colony." December 11, 1911.

———. "Revenue Men Book 8 for Liquor Violation." July 3, 1922.

San Luis Obispo Tribune. December 13, 1879; June 19, 1880; July 24, 1880; February 11, 1882; November 5, 1883.

———. "An Old Building." February 12, 1884.

———. "Out of Luck." April 8, 1882.

Santa Cruz Sentinel. April 3, 1886; April 16, 1886.

Scott, Jan. *The Mistress of Crown Hill.* Performed by South County Historical Society Readers' Theater. Arroyo Grande, California, July 2016.

———. *Voices from Halcyon.* Performed by South County Historical Society Readers' Theater. Arroyo Grande, California, June 2016.

Secrest, William B. *California Desperadoes.* Clovis, CA: Quill Driver Books, 2000.

———. *Perilous Trails, Dangerous Men: Early California Stagecoach Robbers and Their Desperate Careers, 1856–1900.* Clovis, CA: Word Dancer Press, 2001.

Starr, Kevin. *Americans and the California Dream, 1850–1915.* New York: Oxford University Press, 1973.

Stiles, T.J. *Jesse James: Last Rebel of the Civil War.* New York: Vintage Books, 2003.

Teasley, Ross. "Nipomo's William Goodwin Dana." Accessed December 12, 2016. http://www.danapointhistorical.org.

Tognazzini, Wilmar. "The Dallidet Incident, March 16, 1897 through March 22, 1897." 100 Years Ago. Accessed January 7, 2017. www.slocgs.org/Tog.100/scans/Dallidet.pdf.

————. Only Legal Hanging" 100 Years Ago: 1899. www.slocgs.org/Tog.100/scans/Indexes/1899-MT.doc.

"Warren IV (Sloop-of-War)." Naval History and Heritage Command. Accessed December 11, 2016. https://www.history.navy.mil/research/histories/ship-histories/danfs/w/warren-iv.html.

Weister, Kathy. "Old West Legends: The Deadly Dalton Gang." December 2014. Accessed January 7, 2017. http://www.legendsofamerica.com/we-dalton.html.

Wilson, Nick. "Prohibition in SLO County: Bootleggers and Tales of Mischief." www.sanluisobispo.com, March 16, 2016. Accessed January 11, 2017. http://www.sanluisobispo.com/news/local/article67088452.html.

INDEX

INDEX

ABOUT THE AUTHOR

This is longtime Arroyo Grande resident Jim Gregory's third book on local history, following *World War II Arroyo Grande* and *Patriot Graves: Discovering a California Town's Civil War Heritage.* Gregory attended local schools, including the two-room Branch School in the Upper Arroyo Grande Valley; Cuesta College; the University of Missouri, where he received a degree in history; and Cal Poly, where he received his teaching credential. He taught for thirty years at Mission Prep in San Luis Obispo and at Arroyo Grande High School. He was Lucia Mar's Teacher of the Year in 2010–11 and began writing on his retirement in 2015. Gregory is married to Elizabeth, campus minister and teacher at St. Joseph High School in Santa Maria, and the father of sons John and Thomas.

Visit us at
www.historypress.net
...
This title is also available as an e-book